InstaStyle

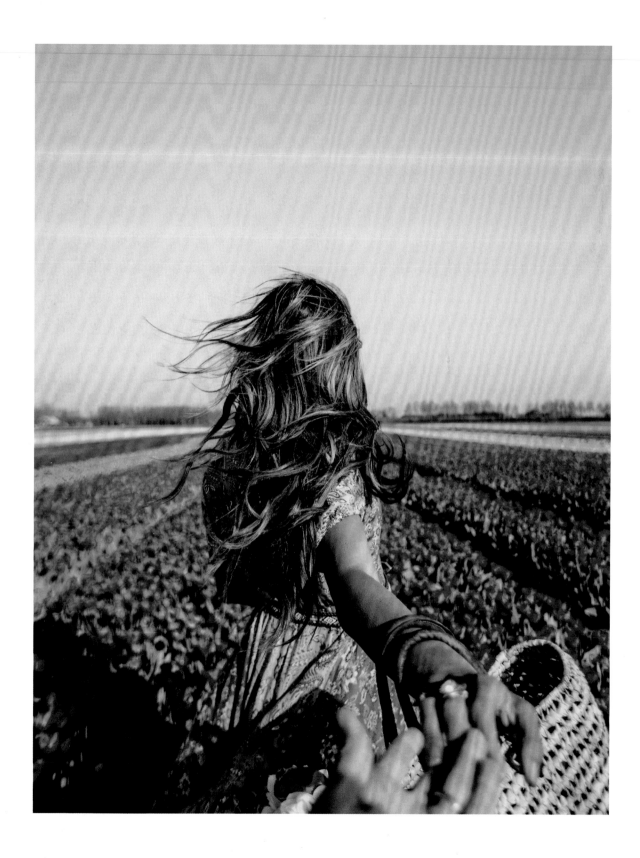

InstaStyle

CURATE YOUR LIFE
CREATE STUNNING PHOTOS
ELEVATE YOUR INSTAGRAM INFLUENCE

Tezza

ALPHA

To my first muse, Sophie Rose

My sister taught me to feel the fear and do it anyway.

You were the sun, I was the storm, and together we made the perfect day.

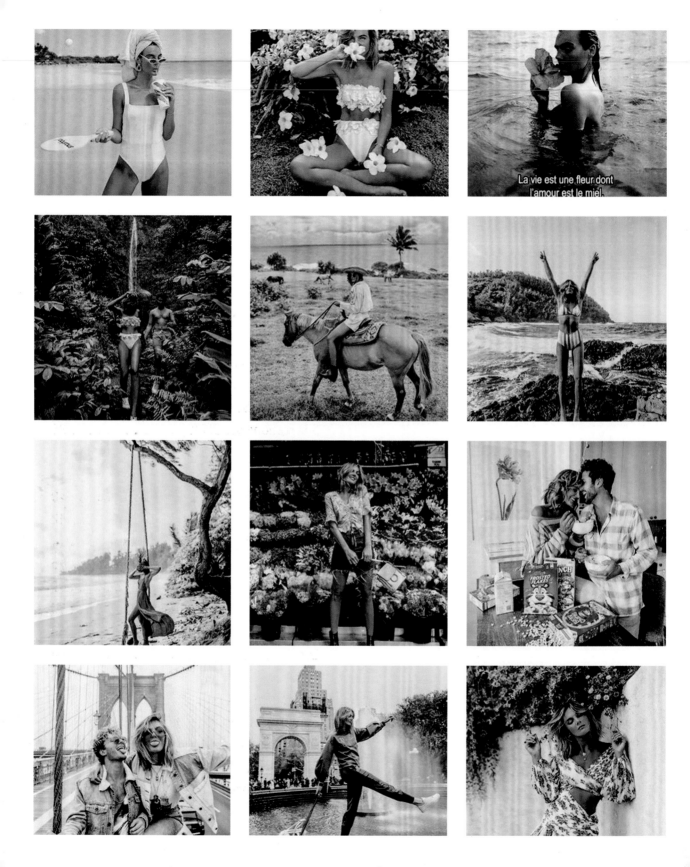

La vie est une fleur dont l'amour est le miel.

Contents

Create

Elevate

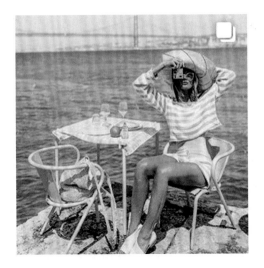

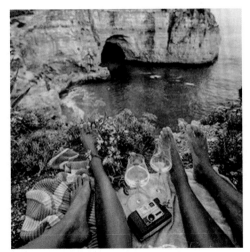

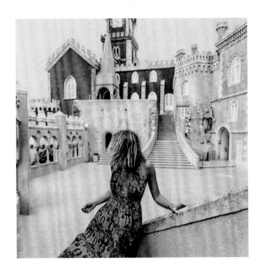

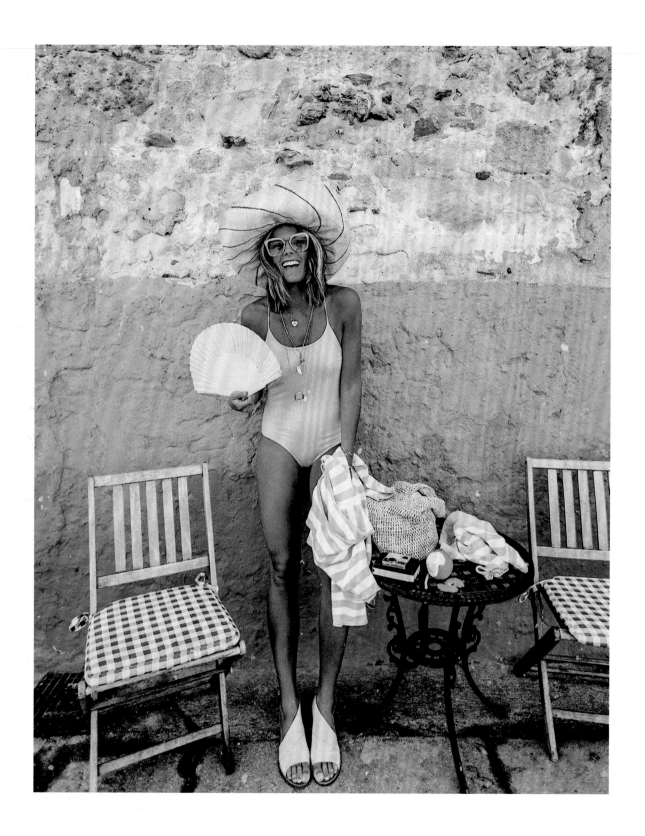

Introduction

I am Tezza, a six-foot-tall girl from the mountains of Salt Lake City, Utah, who grew up in a home surrounded by artists. I was taught not just to dream, but to achieve my dreams. I grew up playing in bands with my siblings, writing music, entering art contests, teaching art classes, and making messes. On top of all this, I was fortunate enough to be able to travel from a very young age. My mind has always been full of ideas, constantly seeing the world with new eyes and wanting to share my vision. I remember when I was 16 years old, I couldn't put down my drawing pad as I sketched different collections in hopes of one day becoming a fashion designer. The next thing I knew, my parents let me run off to live in New York City to attend a summer program at Parsons School of Design. It was in this little 16-year-old moment I discovered myself: a girl who loved to create something out of nothing, who wanted to freeze moments of time and give everyone else even just a second of the joy I felt from being there. I picked up a camera, and the rest was history.

From there I started my own photography business, asking everyone I knew if I could shoot photos of them. I remember I would pull over onto the side of the road when I saw someone cool or interesting, asking them if I could photograph their face, because "wow," it just made me feel something.

I got my bachelor of fine arts from the University of Utah with an emphasis in photography. I started reaching out to fashion brands all over the world hoping we could share a vision and work together. If there is one thing I learned early on in life, it's that you can't wait around for what you want to come to you; you have to go and get it. Ask questions, be curious, be embarrassed, and be remembered—this is how you'll grow.

I'll never forget when Instagram rolled out. I was in college, and all of my "art friends" just couldn't handle that now *everyone* was calling themselves photographers because of this little app. I remember thinking, "No, no, no—this is *amazing*. Everyone is seeing the world in a new way, and I want to be a part of it." As I began to share on this app—mostly embarrassing selfies that, yes, if you scroll deep down on my feed, still exist—a universe opened up. The world went from the unknown to the attainable right inside my pocket. I started making like-minded friends from all over the place and was constantly inspired and pushing myself. Of course, since fashion was always deep in my veins, you know I was sharing my outfits, too (mostly just for me, but hey, sharing for yourself *should* be the point!).

As I slowly started to gain a following, it wasn't the satisfaction of the number that was fun—it was the opportunity to connect with so many people in so little time. Of course, talking about this makes me feel like an ancient grandma who is talking about when phone books first came out or something, but I promise you it was magic. For years, Instagram was a hobby in my pocket, but also a way to help me run my photography business. As people began to gain an interest in my personal life, I would share more of myself.

Life started to fly by as I then got married to the man who is now my business partner, and of course still the love of my life. We moved to NYC with pretty much no plans other than "to make it" doing what we loved. I had no idea Instagram would be the forefront of my business, or even that I could turn my lifestyle into an actual business, but let me tell you, there is nothing more fun, more exhausting, and more exhilarating. If I had known then what I know now...well, let's just say I could have saved a lot of time.

InstaStyle is a book to inspire you to follow your dreams—to create, start a business, and share the greatest parts of your life. Please know there is no perfect formula to this game. What I write in here is from personal experience, asking questions, and learning from others. There are a million ways to succeed; I just hope this gets you there a little quicker, and if nothing else, helps you take beautiful pictures.

Let's get 'grammin'.

Tezza (a.k.a. Tessa Barton)

LIVE. CREATE. REPEAT

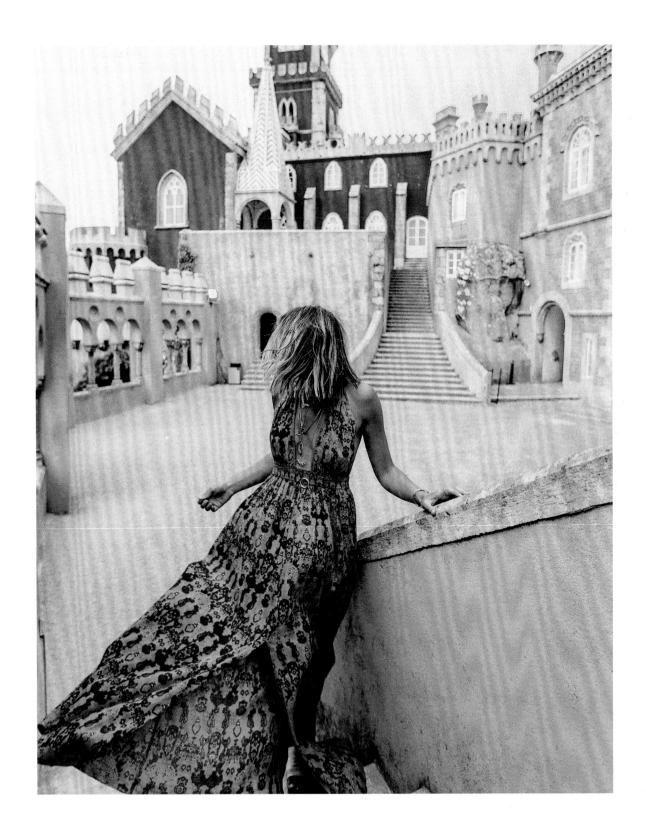

Instabasics

Chart the perfect Insta-course and
get started with the essentials

Why Instagram?

Instagram is the place for you to create your own world within a world. It's a place where you can start a business, share your art, and meet incredible people. It's whatever *you* want it to be! The possibilities are endless.

Express personality

This is a platform for maximum expression. Post a photo, chat on your Story, or write brilliant captions. You have so many ways to create and share your voice. If you have a message you want to spread, a cause you care about, or just a straight-up bomb personality, you will find a following to share it with on Instagram.

Showcase art

There's no better place to share your art. From the world's best videographers and photographers, to fashion designers, graphic artists, and painters, you will instantly be on exhibit in the world's greatest art gallery from the moment you share your first post. Instagram is an amazing way to showcase your art and to discover some of the world's best artists.

Build your brand and business

It's a launchpad. Instagram is the perfect place to build your own brand and launch your very own business. I have experienced this firsthand launching my own brand, *Tezza,* and I know many others who have created incredibly successful businesses that just wouldn't be possible without this amazing platform. Bored of your 9 to 5? You can kiss that goodbye and be your own boss. Instagram is a world full of exciting opportunities.

Connect with friends you haven't met

I've met some of my nearest and dearest friends through Instagram. The user base is surprisingly tight knit and incredibly friendly. I now have best friends from Germany, Brazil, Spain, Thailand, and many other places across the globe. We think similarly and authentically connect, and we never would have had the chance to meet if it weren't for Instagram. You never know what connections could turn out to be a future business partner or best friend. Being open and willing to share experiences and ideas on Instagram can go a long way.

GO MOBILE

Instagram is the premier photo- and video-sharing social networking app, and it's designed to be an entirely mobile platform for on-the-go use. Connection and inspiration are always at hand. While it's possible to enjoy a few of its functions on a computer's internet browser, it's optimized for smartphones. In fact, the only way to post your own content is from a mobile device.

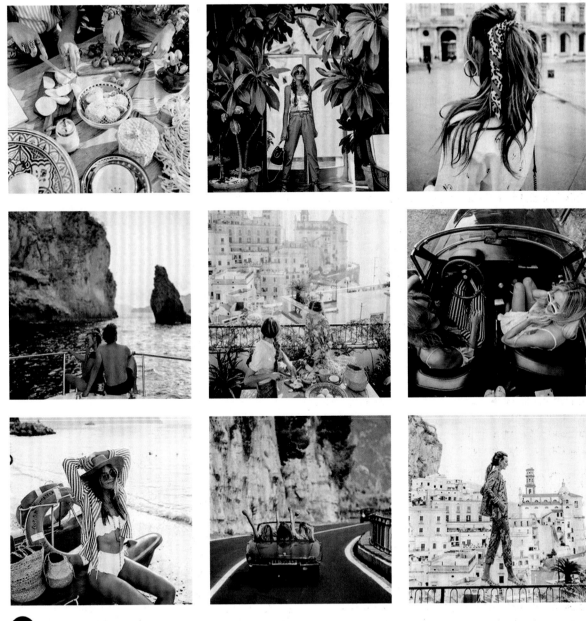

#tezzaitaly #tezzatravel

Are you up for it?

Instagram is a grind. The more time and effort you put in, the greater your chances of success. I am incredibly lucky that I found something I love to do and am part of such an amazing community—*but,* it does take a ton of really, really, really hard work. Not only do you put an insane amount of time and energy into it, but you are constantly tossing yourself out to the world and letting everyone into your life.

Gotta work for it

Truth be told, I'm never not working. I'm constantly planning posts, gathering inspiration, scouting locations, styling outfits, and meeting with brands. It's a 24/7 job. Granted, it's a pretty dang good 24/7 job, but it really can be exhausting. It's important to know that before jumping in. It takes pushing yourself every day to come up with something new and finding ways to stand out and be different.

You might fail

You just spent hours planning a shoot, finding the perfect outfit and location, scheduling time with your photographer, and you think you've nailed it. You get back to your place and edit your photo. It's feeling so good it could be on the cover of *Vogue.* You toss it out to the wild world of Instagram and... flop. It hardly gets any likes. What the—?! This can hurt, and it's never fun, but it's okay. Not every post can kill it like a Kim K. selfie. You have to shake it off and try again. Nobody gets it right the first time. Every failure is a chance to learn about what works, what your audience likes, and what you're good at. Keep your chin up. Stay true to yourself and your brand, and the rest will work out.

Hello, world!

It takes a ton of energy producing killer creative work every day. Not only that, but you are also opening yourself up to the World Wide Web. Hello! It can be a little nerve-racking, and there can be a lot of pressure. Luckily Instagram is a very supportive and positive community. There is the occasional rude comment or creepy person sliding into your DMs, but it's important to let that slide off your back and keep doing you. Because let's face it, you're going to kill it, and haters are gonna hate.

No one is you, and that is your power

I remember the first time I heard that quote. It was like a heavy weight was lifted off my shoulders, and I realized that *I* was all I needed to be successful. Being *you* is your greatest weapon. Whenever you feel discouraged or start comparing yourself to others in the Instagram world, take a step back, think of this quote, and forget the rest...because you already know what to do.

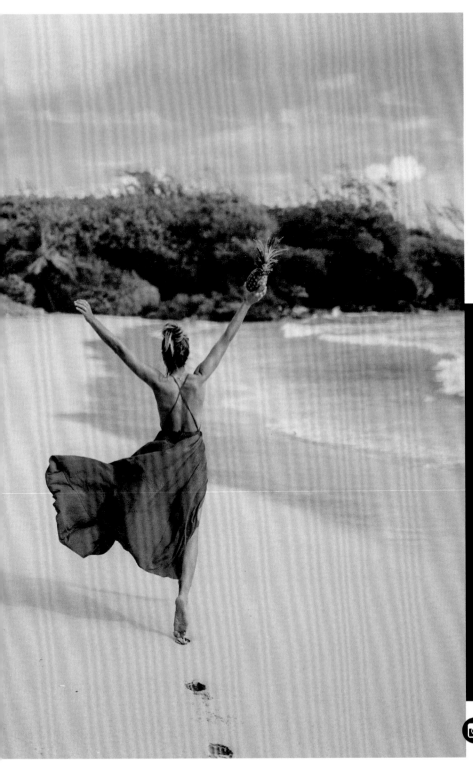

DON'T DO IT ALONE

Building a successful career on Instagram takes an incredible amount of time, effort, and grit, and doing it alone would be nearly impossible! Try to find a partner or team to create with you and support you through the many ups and downs that come with building your Insta-empire. I am so lucky that I found my business partner in my husband. We love creating and working together, and having each other as a support system is so important. Try to find your partner in a friend, family member, or fellow creative to help see your vision through.

Walkin' on sunshine

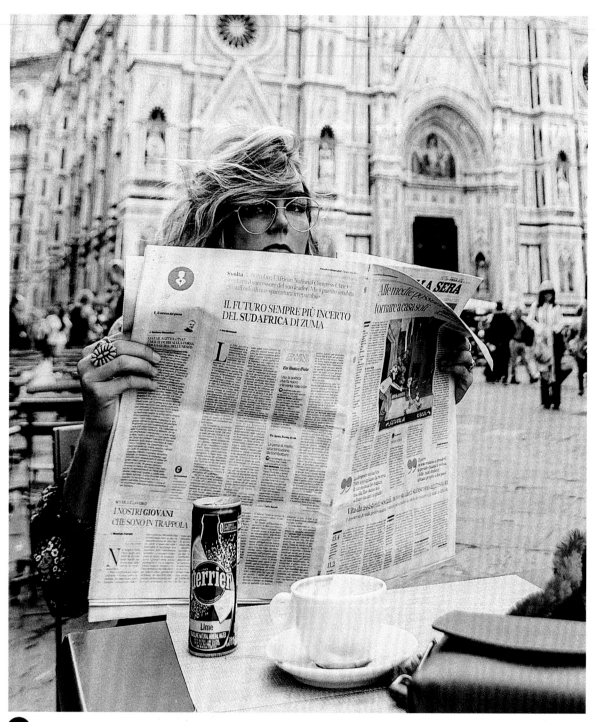

Dove è la pasta?! Lunchtime in Firenze

What you have to gain

The Instagram marketing and influencer space is incredibly hot right now. As attention shifts away from traditional forms of media and toward social media networks such as Instagram, so do the marketing dollars of big brands. If you're a good content creator, there is so much opportunity to build a business, and new opportunities are coming up every day as more brands and influencers enter the space.

Hot biz coming through

The Instagram marketing space is hot right now—like bubbling-lava-on-the-back-of-a-missile-headed-toward-the-sun hot. By some estimates from industry experts, it's a $1 billion market. Yes, that's billion with a *b*. Instagram is where styles break and where tastes are made. Every major brand is jumping in, wanting to work with Instagrammers with follower counts ranging from the low thousands to the millions. Not only do you get the opportunity to work with dream brands you've looked up to your whole life, but you also get the chance to launch a brand of your very own. I have friends that have created brands on Instagram in all different industries. You're incredibly close to your customer, and it's the perfect launch pad to take your business or idea to the next level. There are sales tools and powerful analytics that can help you get to the next step, as well as an incredible network of like-minded people.

Be your own boss

I have loved pursuing this career path because it allows me to be my own boss. My feed is my brand, and I am the Creative Director and the CEO. It's awesome! I love waking up every day knowing that I have the opportunity to push my brand and grow. My success is determined by me and how hard I work.

What do you have to gain? Everything. Start a new career, work with people you've always admired, launch a brand of your own, and build a worldwide network of kind, interesting, and talented people. Jump on in!

The language

Instagram definitely has its own lingo. You should be familiar with these terms as you dive in.

Influencer
A common label for anyone making a career on Instagram, or at least for anyone building a follower count in the thousands. Influencers do just that—they influence. They impact followers' tastes through brand messaging.

Feed
Your home screen. It's where you see the latest posts from the people you follow. The order in which photos appear on your feed is determined algorithmically, meaning Instagram tries to intelligently show you the posts it thinks you most want to see.

Handle
An Instagram username. It's designated by having an @ symbol preceding the name. Mine is @tezzamb.

Follow
When you follow an account, their new content loads on your home screen. When others follow you, your posts will then appear on their home screen.

Post
A photo or video that has been uploaded to Instagram. Your posts appear in your followers' feeds.

Grid
The grid of images, always three photos per row, that you see on an account's profile. Maintaining a beautiful, coherent grid is important for enticing people to tap "Follow" when they stumble upon your account.

Like
Instagram users "like" a photo when it resonates with them. This is done either by double tapping the post on the phone screen, or tapping on the heart icon under the post. Posts accumulate a *like count*. This is the core metric for measuring a post's performance and follower engagement.

Comment
Anyone can leave a comment under a post, demonstrating a higher level of engagement than a like. It's another great way to engage with other Instagram users. Similar to likes, a post's *comment count* is a good measure of performance.

DM
Stands for Direct Message. This is a private message you can send to another Instagram account. It's a great way to get new business, meet new people, and engage with your following in a more intimate way.

Stories

A feature that lets you post photos and videos that will disappear after 24 hours. Content shared to Stories appears at the top of the home page but doesn't appear in your grid as a post.

Highlights

Group old Stories together in a permanent section that sits below your Instagram bio. You can make Highlights out of anything you've shared to your Story in the past.

Live

Broadcast videos to followers in real time. You can then save these for users to watch even when you're done streaming.

Private and public accounts

While anyone's account is discoverable on Instagram, only a public account's posts are visible to anyone stumbling upon a profile. Private accounts must *accept* each of their followers to grant access to see their posts. If you want to be an influencer, your account needs to be public.

Archive

Move any post you've previously shared into a space that's visible only to you. You can hide any post without actually deleting it.

The Instagram landscape

Instagram is the world's fastest-growing social media network. It has a worldwide user base, a fun and engaging community, and is packed full of talent. Whether it be working with a brand you've always dreamed of working with, or building something amazing with a fellow Instagrammer, there is opportunity around every corner.

What's out there

The overall Instagram population is huge—over 800 million users and growing. Personal brands, as well as businesses, know that Instagram is the best place to launch and promote themselves. Within the greater Instagram universe are many categories. If you are into art, fashion, fitness, food, or anything in between, there is a community for you to jump into. The vast possibilities on Instagram are definitely becoming more mainstream and recognized, meaning more of the brands you love are spending money on high-quality content creators like you.

Instagram is a place for anyone with knowledge, passion, authenticity, or credibility.

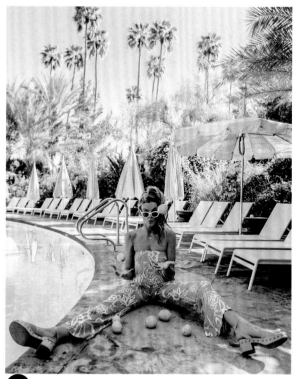

Peaked at age 7 as the founder and CEO of the world's best lemonade stand.

The niches, and a little help from my friends

With a variety of diverse niches comes a variety of talents and insight. I have friends who kill it in their Instagram spheres, and they're going to unload some of their knowledge in the **Create** chapter to help inspire you to tell your own story (see p103). These are some of the broadly categorized niches, but of course there is lots of crossover, and new territory is always being shaped.

+ **LIFESTYLE** *Yours truly, bringing to Instagram a big smoothie of my favorite things. I basically live to create. I want to teach you how to showcase all the awesome parts of your life, too.*

+ **FASHION** *Emily Luciano, @emily_luciano, has style, and she knows how to showcase it. Her fashion content makes T-shirts, dresses, and Gucci all look natural in the NYC streets.*

+ **TRAVEL** *Aggie Lal, @travel_ inhershoes, visits every corner of the globe, from remote to bustling, posting some of the most beautiful and creative travel content on Instagram.*

+ **FOOD** *Erin Jensen, @thewoodenskillet, infuses her food feed with the beauty of fresh ingredients and vibrant colors. Her photographic style is crisp, food-centric perfection.*

+ **BEAUTY** *Alanna Durkovich, @xandervintage, pushes beauty trends to unexpected places. Her effortless and edgy looks influence followers to embrace those glam finishing touches.*

+ **FAMILY** *Amber Fillerup Clark, @amberfillerup, shares the funniest and most charming family content. The only things more beautiful than her hair are her two kids and her husband.*

+ **FITNESS** *Alexa Jean Brown, @alexajeanfitness, is fit and fab. Her beautiful workout and lifestyle content encourages her followers to commit to their healthiest, fittest selves.*

+ **INTERIOR DESIGN** *Anne-Marie Barton, @annemariebarton (hey, mom!), knows the power of an alluring space. She creates and captures the beauty of design for her followers.*

+ **FLAT LAYS** *Carissa Smart @designbyaikonik, has top-notch taste. She's perfected the art of flat lays and product photography to communicate that taste to her audience.*

Follower count, fear not

It's easy to look at massive Instagram accounts with hundreds of thousands or millions of followers and feel like you're never going to get there. And guess what? You may not get to a million followers, but that's okay. There's room for anyone with a following, big or small. Not only are there niches within Instagram, but there are niches within those niches. Sometimes a brand doesn't have the budget to work with an influencer with a million followers. Even if you have one one-hundredth of the follower count, but still have a killer personality and an engaged audience, you're a prime target for collaborations with those brands. So don't get too overwhelmed; you have a unique perspective and story to tell, and you will find success in your own niche.

Find your place

Start exploring Instagram, and you'll find hundreds of different universes sharing different types of information with varied audiences and personalities. These spheres can all have dramatically different aesthetics and types of content, and they all work. Use the Instagram Search and Explore functions to see what's out there. Let yourself enter into a click-spiral, jumping from place to place, tapping on hashtags, location tags, and user handles. This will start to shape your understanding of the platform and what's out there. Mentally note what you like and don't like, what's successful and not, and where you ultimately want to fit.

Q
DISCOVER

Instagram's mobile platform makes it super easy and addicting to discover content. Here are some ways to explore the Insta-universe and enter into your very own click-spiral:

+ Tap the magnifying glass icon and start typing in the search field. You can toggle between searching different types of content (e.g., hashtags or users).

+ Tap on the magnifying glass icon, and scroll through the posts Instagram thinks you might be interested in.

+ Navigate to a profile that interests you, and open the "Suggestions for You" tab to see similar accounts. Check out the ones that look compelling.

+ Click into individual posts and Stories, and follow any clickable links, including users who like or comment on the post, people tagged in the photo or caption, location tags, and hashtags.

STICK WITH IT

Stick to your art and authenticity no matter what you think the current trends are. If you're creating something beautiful, remaining authentic, and providing a unique perspective, you will be much more successful and fulfilled down the road.

Determine your mission

Determining your mission is sooo important! It will help define what type of photos you post, who you want your audience to be, and the voice you will present. It will also make creating content on Instagram more enjoyable and meaningful, knowing that you're making it to achieve a higher goal. It can be anything from providing style insight, inspiring confidence, or offering nutrition advice. Your mission is what makes you unique, keeps you inspired, and is ultimately the reason others will follow you.

Ask your friends

One great way to help define your mission is to ask friends and family what they would come to you for if they needed advice. This is a great way to get some perspective on your unique talents and abilities. It'll help you discover what people find most inspiring about you. You may learn something totally new about yourself, which will shape your mission.

Some days you eat salads and go to the gym; some days you eat cookies and refuse to put on pants. It's called balance.

Solve a problem

Another excellent way to define your Instagram mission is to solve a problem. Take a look at other big Instagram accounts in spaces that interest you. Write down some notes on what they do well and what they don't. Perhaps there is a problem that only you can solve!

My mission

I want to give my followers a glimpse into a new way of seeing the world. I encourage them to create and to see their lives the way they dream. I give everyone a good laugh in my captions and hopefully encourage them not to take life too seriously. I try to teach my followers to live the "art of life"—to find beauty in the mundane, and to take something ordinary and tweak it just a few notches to make it a work of art.

✏ Write it down

Before you get started, it's essential to clearly define your mission statement. Write it down so you can make it a reality out in the world. Tape it up on your mirror or above your door, and lovingly slap it as you leave your place. Whatever you need to do to turn your mission into reality, do it. Whenever you're in a creative rut, you can refer to it and remember the way you felt when your first wrote it down.

Create your account

Once you have your mission defined, there are three super important steps to creating your account. This stuff should be taken seriously! It's how you'll be known on Instagram and in the world, as some people may only know you by your Instagram name. Yes, I know—totally wild, and no pressure at all.

1. Pick your handle

This should be memorable, easily pronounced, and easily spelled. You can use a witty combination of your name, think of a handle that relates to your mission, or even make up a new word. People may refer to you by your handle more often than your real name. Brands, friends, and followers will also want to look you up, so making it memorable and unique is important. My handle is a combination of my nickname and my initials. Growing up, my friends would always call me Tezza, but @tezza was not available. I added my middle initial, *M* for Marie, and my last initial, *B* for Barton. Voilà—@tezzamb.

While it's possible to change your handle at any time, it's not advisable without a really good reason. You want your brand to grow and stick in people's minds. Changing your name is like starting over.

+ **Your first choice isn't available?** Try adding an initial, using your nickname, or adding an underscore where it makes sense.

+ **Make it easy to remember.** Don't add unnecessary characters that don't make sense, or purposely misspell words that will be difficult to remember. For example, don't add too many of the same character in a row, like @tezzzzzzamb, and don't get too crafty with the underscores, like @xo___xo_tezzamb_xx. Stuff like that will be crazy hard to search, and limits your discoverability.

profile photo

handle

Verification Badge: awarded by Instagram on a case-by-case basis to indicate that an account is authentic

tezzamb ✔️ [Follow] [▾] • • •

3,033 posts **482k** followers **1,885** following

Tezza 📍NYC Musician • Creative Director • Stylist • Traveler
Taste the rainbow 🌈 @thebanddoe Shop photo presets
/Collage Kit 🌱 @shoptezza
www.shoptezza.com

bio

2. Select a profile photo

Unlike your driver's license photo, you have limitless tries to get this right. Take inspiration from your favorite accounts, try out a bunch of options, and nail it. Be you, be real, and reflect your mission through your profile photo. It's a great way to tell a story and give people a sense of what your account is all about, all without saying a word. People will start to intuitively connect your profile photo icon with your brand, so this is your chance to make something iconic and recognizable.

+ **Use a photo in front of a clean, simple background**. People will see this picture while scrolling quickly through their feeds, and it will be quite small. Make sure to keep the background simple and clean so your followers can clearly make out the subject of the photo.

+ **Take care when cropping**. Include the top of your head and the sides of your face. Stay centered and clear.

+ **Tell your story.** Reflect your brand in one little photo. Are you a foodstagrammer? Show yourself eating a delicious plate of food. All about the fitspo? Maybe capture something of you working out. This lets potential followers get to know what your account is about before visiting your feed.

+ **Logo or picture?** If you are strictly a brand selling a product and carving out your social niche, it makes sense to use your logo to increase its recognizability. However, if you are an aspiring blogger or influencer, use a photo of yourself. People like to connect with other people.

3. Write your bio

This is your elevator pitch to the world. Keep it short, simple, and attention grabbing. As people stumble onto your feed, they'll decide whether to follow your account in seconds. What is your mission statement, and how can you communicate it in a few words or snippets? What are you passionate about, and how are you going to show it? There aren't any rules for what you can and can't write here. As long as it reflects you and represents your voice, let it shine in your bio.

+ **Try to keep it to three lines or less.** People are only here for a split second, so make it super easy to digest.

+ **Include a hyperlink.** Have a killer YouTube channel? A must-read blog? Want to link content from a recent post? This is the place for it. Links help drive traffic to other online content. If a hyperlink is long or complicated, use a service such as Bitly to create short, custom links that direct to your content.

+ **Keep it up-to-date.** If any of the information or links you have in here are no longer relevant or correct, update them ASAP.

SWITCH TO A BUSINESS ACCOUNT

It's easy to switch from a personal to a business profile. All you need is a Facebook account to set it up (and you can convert it back at any time). With a business account, you receive tons of useful insight, such as demographic info, when your followers are active, most liked posts, and more. You'll better understand your audience and what they want so you can build the best content possible. I've found these tools to be so worth it.

Of course if you're an actual business, this is a no-brainer. You can set up buttons that allow customers to easily get in contact with you, as well as provide directions to a shop.

Aim for engagement

Engagement—real people interacting with your posts—is the goal. It's the benchmark for measuring your performance and capturing the attention of brands. (It's NOT all about your number of followers!) Buying followers to get started can be so tempting, but whatever you do, don't do that. Build your brand honestly, and it will pay off down the road.

It's not about the follower count

Brands working with influencers are paying attention to how real and engaged a person's following is. It's not enough just to have a massive follower count; your following must be real, active, and engaged for a brand to want to work with you. Brands know that what you may lack in reach, you more than make up for with engagement. An engaged following knows you, trusts you, and is much more likely to be influenced by your content.

Marketing specialists are paying attention to this number to determine whether your presence on Instagram is relevant and influencing others. As the industry continues to grow, brands will become even more shrewd and discerning before working with an influencer. Build your following the real way, through great content, a powerful message, and an authentic voice. It's so worth it.

Growth is relative

Before you start freaking out over your engagement number, recognize other factors that influence engagement and sway marketers:

+ If you're just starting out, your follower count hasn't steadied enough, and you haven't had enough time yet to create your impact. Give it time.

+ Growth may not be constant and will have its fair share of ups and downs. Breathe...this is totally normal and to be expected.

+ Marketers may also consider other metrics, such as rate of follower growth, clicks on bio URLs, or growth of promotional hashtags.

MEASURING ENGAGEMENT

Engagement is typically measured by how many likes and comments your posts get. For example, if you see someone with a million followers, but they only receive 500 likes and 12 comments on a post, then they have very poor engagement, and possibly a shady following. Low engagement like this suggests followers are not real, do not like the posts, and are not influenced by the account.

This formula measures your engagement factor:

$$\text{Engagement rate} = \frac{\text{Average number of likes in 4th through 10th most recent posts (7 posts total)}}{\text{Total number of followers}}$$

1–4%	AVERAGE
4–8%	ABOVE AVERAGE
8–12%	GREAT
Above 12%	EXCELLENT

The higher the percentage, the more authentic the following, and the more likely you will work with killer brands who recognize your influencer status.

Post	Likes
1	33.5k
2	33.0k
3	29.3k
4	32.1k
5	68.0k
6	33.3k
7	43.1k
8	38.6k
9	31.9k
10	42.4k
11	43.0k
12	19.9k

Slow and steady follower growth usually wins the race!

To measure my engagement rate using the formula from above, assuming that post 1 is my most recent with 33.5k likes, and I have 481k followers, I'd plug the numbers in like this:

$$0.086 = [(32.1 + 68.0 + 33.3 + 43.1 + 38.6 + 31.9 + 42.4) \div 7] \div 481.0$$

At this snapshot in time, my engagement rate is great at 8.6 percent!

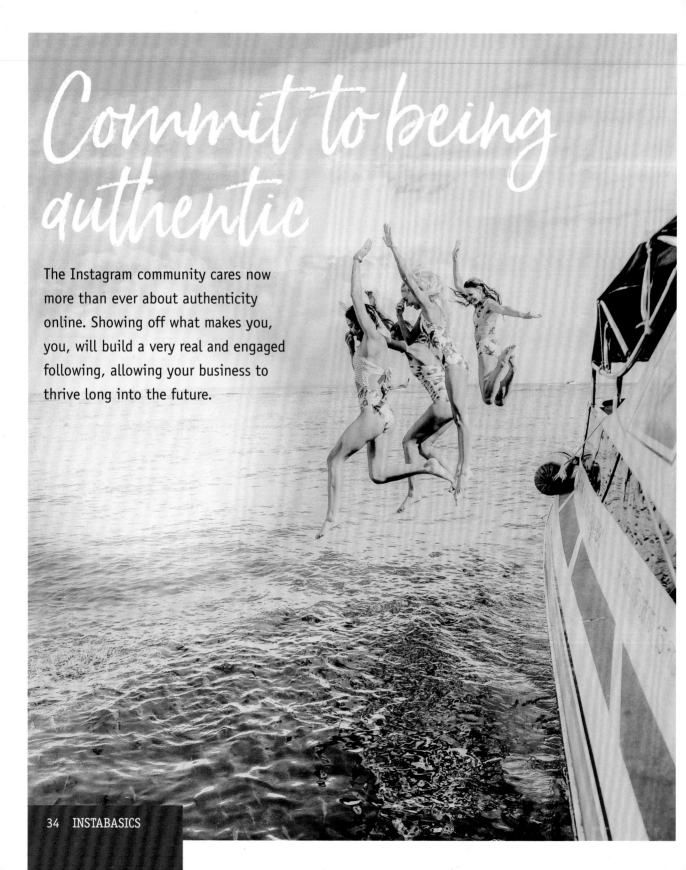

Commit to being authentic

The Instagram community cares now more than ever about authenticity online. Showing off what makes you, you, will build a very real and engaged following, allowing your business to thrive long into the future.

Reveal the real you

The key to building an engaged audience is being yourself. If you stay true to you and create unique content, your following will find you. All of these pieces signal to your audience that you're sincere:

+ **Easy on the retouching.** It's okay to do some retouching here and there. Have a big zit? Photoshop that thing outta there! These tools are wonderful for the occasional bad skin day, but don't abuse them. If you retouch your photos too much, it's very obvious, even to the casual observer, and will lead to people thinking you're a fraud.

+ **Don't try to be someone you're not.** Do it for the 'gram! We've all heard that while capturing an epic selfie, but that doesn't mean it applies to you and your personality on the 'gram. Don't try to be someone you're not. Stay true to the story you want to tell.

+ **Mix sponsored content in with your real stuff.** It's important to keep a good ratio of sponsored and not sponsored posts in your feed so your followers don't think you're one giant advertisement. I usually try to do five to six personal posts for every one sponsored.

+ **Be stingy with the brands you work with.** Make sure the brands you collaborate with share a similar DNA and vibe with you. This is super important because it will allow you to earn money and build your list of clientele without sacrificing authenticity. You're a fitness Instagrammer collaborating with Taco Bell? That won't fly with your followers.

People like people

I've definitely noticed while building my Insta-brand that people like people. We're social creatures, and we want to connect with others, especially others who are authentic, real, and relatable. The more "you" that you are, the more others will feel like they relate with you. This makes your followers much more interested in participating and engaging in your story. It's okay to show human things—be honest in your captions, and maybe toss something vulnerable into a Story post.

An authentic you guarantees an authentic following.

I walk around like everything is fine, but deep down, inside my shoe, my sock is sliding off.

Smartphone vs. DSLR

The great debate! Both options have their fair share of pros and cons. What a smartphone boasts in terms of portability and ease of use, it severely lacks in photo quality and lens options. DSLR cameras are heavy, bulky, and have a steeper learning curve, but the photo quality is amazing. With the amount of lenses and high-powered software available, shooting with a DSLR opens up immense possibilities.

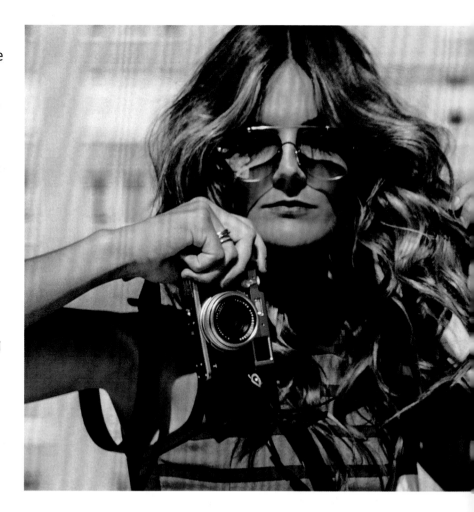

Smartphone

Advantages

+ Easily transportable

+ Easy learning curve

+ Almost anyone can help you snap a photo, so you won't need to hire a professional photographer as often

+ Helps you achieve a more effortless vibe

Disadvantages

+ Smaller resolution—if you want brands to buy your photos for print or web use, they may request high resolution files

+ Lower image quality

+ Less editing flexibility

+ Limited lens and focal options—the phone lens is the only one you get

DSLR

Advantages

+ Amazing photo quality and detail

+ Different lens options help you create different styles and inspire you to capture varied angles, etc.

+ Full advantage of powerful editing tools, such as Adobe Lightroom and Photoshop

Disadvantages

+ Heavy—it can be annoying to always tote it around

+ Expensive

+ Bigger files take up more space on your computer hard drive

+ Intense learning curve; it can take several years to gain competency

+ You will likely always need an experienced photographer

A mixed approach

Sometimes you can't bring a big ol' DSLR with you, and you need to be more mobile and flexible. Other times you may need to step up your photography game for a big campaign or for a special shoot, and a DSLR is needed. It's totally okay to mix it up. Advancing your skills in both smartphone photography and with a DSLR will only enable more opportunities.

It's important to be able to capture moments and create content anywhere and everywhere. Brunch with the fam turns out to be an epic moment? Whip out your phone and make it happen. You're hired by a hairspray company and want to nail that Farrah Fawcett look? Time to fire up the Canon and the leaf blower and capture those locks billowing in the wind like only a DSLR can.

It's important to be able to capture moments and create content anywhere and everywhere.

Curate

Organize and showcase your life with an
irresistibly curated Instagram grid and posts that
relate to your mission every time

Define your story

Everyone has one, and everyone loves a good one. Are you from a super cool town or making your way in a big city? Are you an artist or a poet with a message to share? No matter what it may be, Instagram is a place to share your story and connect with others. The first step to creating a great account is solidifying the types of content that best tell your narrative.

Content that tells your narrative

The best accounts have a unique message, fill a void, or solve a problem for their followers. These are the ones with a defined mission that drives the entire feed (see p28). Now take a step back and think about all the parts of your life—**your story**—that serve and shape your mission. What do people come to you for in day-to-day life? What risks do you take? What do you love? Maybe you have killer style advice, are embarking on a scary new adventure in life, are a makeup wizard, or a travel guru. Each of these themes are a part of your narrative, so the content you share should reflect them.

Friends and family have always come to me for photography and style advice...

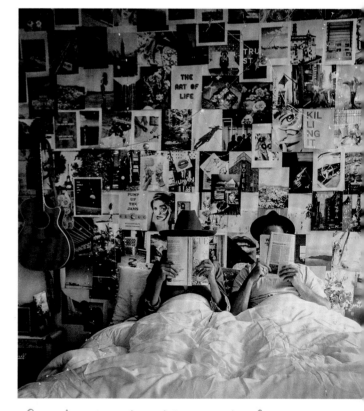

...My husband and I moved to New York City on a whim to chase our dreams...

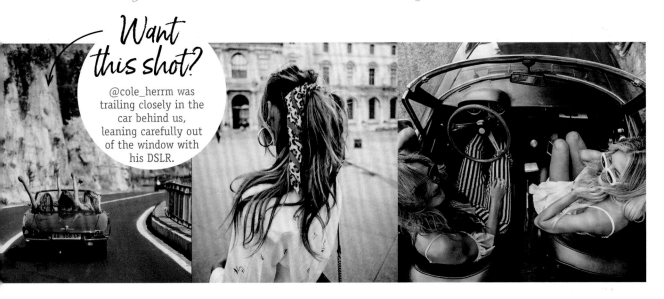

Want this shot?

@cole_herrm was trailing closely in the car behind us, leaning carefully out of the window with his DSLR.

...On Instagram, I get to share all these pieces of my story; I inspire others to take fashion risks, chase their dreams, and hone their photography skills.

Write it down

Jot your mission statement on top of a piece of paper. Now think about the themes of your story that shape your mission: pieces of your history, the minutiae of your day-to-day grind, and the areas of your life that continue to unfold. Make a bulleted list for these main content areas, or journal briefly about each element of your story. These meaningful bits of your life, everything from the momentous to the trivial, will be the foundational building blocks of every post you share with the world.

Come one, come all

Don't be discouraged if you're feeling like your story lacks the pizzazz to become a successful account. I follow big, flourishing accounts that share their unique stories from different perspectives all across the board. I follow everyone from chefs and interior designers, to business experts and writers. If you are an expert in a field that isn't necessarily hyper-visual, that's totally okay. There are still novel and exciting ways to tell your story on Instagram. Some of my favorite accounts post poetry or business inspiration and are not actually sharing beautiful photographs at all. They may make simple videos of themselves talking about their message or post clean text photos of their poetry. Whatever your talents and passions, Instagram is a great place to build your platform and share your story.

Create post categories

All right, you have your story nailed down. Now think about different categories within those overall themes. I am a fashion, travel, and lifestyle blogger. Categories that fit within my feed encompass everything from my favorite food spots, to upcoming fashion trends, to travel tips. You don't have to define yourself into one space (don't let this stress you out), but simplifying your brand helps you focus and understand who your followers are.

Break it down

Dividing your posts into some broad sub-categories will help you stay focused and avoid feeling overwhelmed. Instead of thinking "I need to get great travel photos today because that's my story," sort it out into something more manageable. Specific sub-categories, such as "Let's get a brunch photo, a beach photo, and hotel room photo," help you handle your posts. Each of those photo ideas fit within the travel realm, but they are much easier to grasp and brainstorm rather than the big, broad idea of just "travel."

Want this → shot?

NO ONE'S AROUND?
Set-up a tripod and use the self-timer to capture moments with a significant other

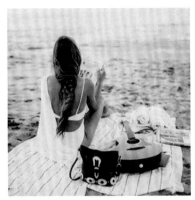

Sub-categories on my feed

I fit generally within the fashion, travel, and lifestyle niche. For example, some fashion sub-categories within the theme are:

+ Street style
+ Outfit of the day
+ Style tips

Some lifestyle sub-categories include:

+ Restaurant and out-to-eat
+ Friends, family, and relationships
+ Hair pictures
+ Daily activities (farmer's market, buying flowers, etc.)

Having these post categories is really nice for organization, brainstorming, and mixing up my feed. Your categories don't need to be super rigid, but it really does help. I will gather inspiration for these types of posts and keep them for future reference, which I cover in more detail on the following pages.

Highlight your favorite snacks at home or abroad; food is a natural fit in the lifestyle category

*Traveled to Laguna Beach with @cole_herrm.
Post sub-categories help me create a grid that is diverse and lively, while still remaining coherent.*

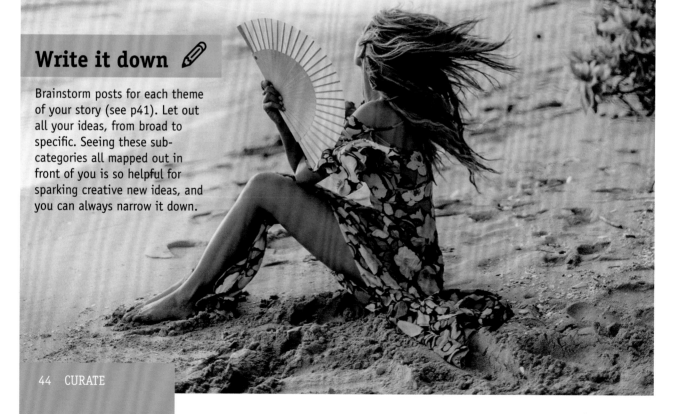

Brainstorming for post categories

Making an ideas list helps so much when you're in a bind, trying to think of new ways to connect with your audience and provide original and refreshing content that fits within your story themes. My biggest tip: think outside the box. What information do you have that no one else is sharing? What's your secret ingredient? Once you begin posting, you'll start to notice what performs well and draws your audience. Listen to them, as they will help you grow your brand and give you an idea about what is sticking.

Write it down ✏️

Brainstorm posts for each theme of your story (see p41). Let out all your ideas, from broad to specific. Seeing these sub-categories all mapped out in front of you is so helpful for sparking creative new ideas, and you can always narrow it down.

Here is some inspiration to help get you started with your own ideas:

Health

+ Favorite workout gear
+ Nutrition suggestions
+ Workout routine
+ #Tuesdaytips
+ Progress reports
+ Before and after

Fashion

+ Seasonal trends
+ How to style this
+ Tutorials
+ Day to night
+ Makeup tips
+ What's in my bag?

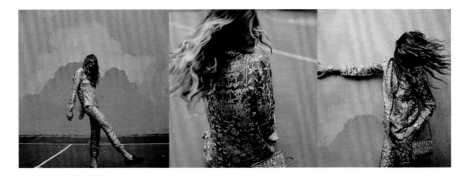

Lifestyle

+ Your relationship
+ Photography tips
+ Decorating ideas
+ Favorite restaurants
+ City guide
+ Staying motivated

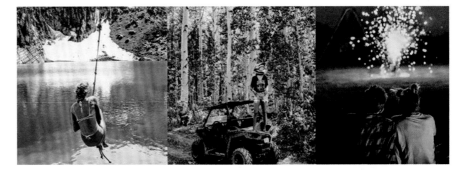

Travel

+ Sightseeing
+ At the hotel
+ Out to eat
+ Packing necessities
+ Must-do activities
+ Like a local

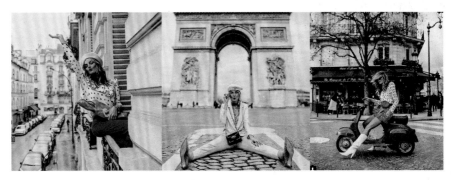

Get inspired

We're lucky to live in an age when there is endless inspiration from Tumblr to Pinterest to magazines (and of course Instagram). Not only are these platforms chock-full of inspiration, but they also have tools for gathering and organizing that inspiration. You can constantly build your mood board to keep your ideas fresh and your content exciting. Here is a breakdown of my favorite places to find inspiration, and some tips on how to use them.

Pinterest

Pinterest is just about perfect when it comes to finding, gathering, and organizing visual inspiration. I find that it's packed full of gorgeous photos, and I'm always stumbling upon something that inspires me to create something new. I start new Pinterest boards in preparation for upcoming shoots, and I have ones that I've had for years to which I'm always adding fresh material. I also love creating new Pinterest boards ahead of going on trips—I pack them full of shoot locations, restaurants, hotels, and anything else that may be useful so I'm totally prepared before I even get there.

Tumblr

Tumblr is another handy platform to find inspiration, and it's a little more diverse and interactive than Pinterest. You can follow your favorite Tumblr blogs, and either repost or save their posts. People post all kinds of content here, not just photos. You can find poetry, GIFs, videos, and even music. It's a great place to find inspiration that hits all of your senses and surely produce some amazing new ideas for your Instagram posts.

Magazines

Oh, long forgotten magazines. They definitely seem retro in this digital age, but I absolutely love them. There's something so special about physically holding something, and there are some absolutely beautiful magazines out there. If you're lucky enough to live in a bigger city, you will likely be able to find magazine shops with hundreds of beautiful options. Barnes & Noble also stocks gorgeous magazines. So buy some magazines that look interesting, flip through them, and tear out the pages that excite you.

DON'T BE A COPYCAT

It's important to feel inspired and look for things that give you ideas, but be cautious of becoming a copycat. Being inspired and copying are two different things. Make sure you're doing it your way, and not just trying to be someone else. It's important to remain true to yourself and put your artistic stamp on something. All content creators should be respected, so don't copy, and give credit where due.

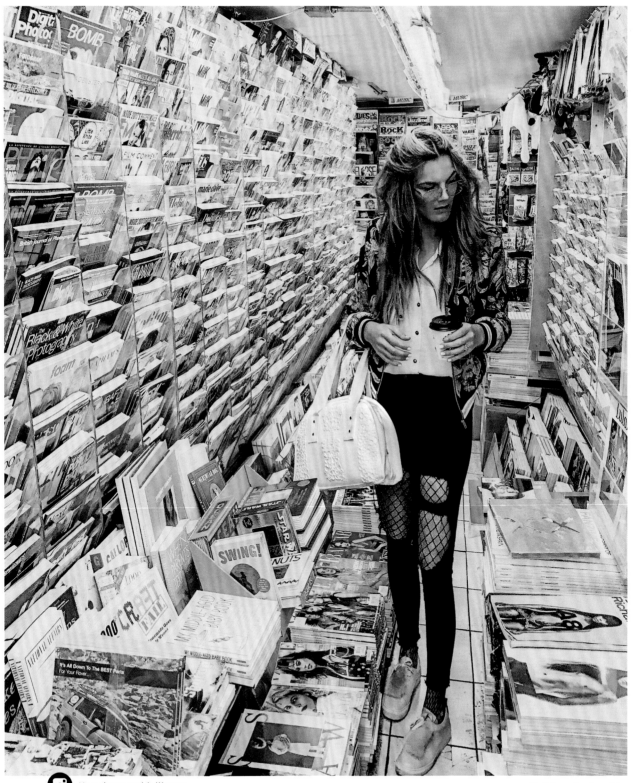

Flag what you love

What's that? You can bookmark your favorite images on Instagram, and even separate them into your own collections? YES! When this flag feature came out, everyone jumped for joy because they no longer needed to screenshot all of their favorite things on Instagram, only to have the screenshots be lost to a dense and disorganized mobile photo library. Bookmark and organize any post you like on Instagram for later reference.

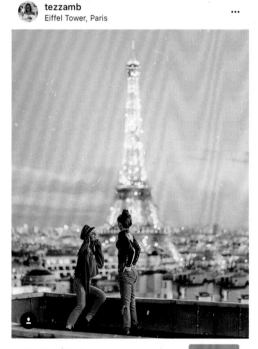

Using the feature

Flag travel ideas, food places, shooting locations, photo inspiration, memes, recipes, artists, and workouts...the possibilities are endless. When you are in a bind, this is the best way to remember your favorite things and get inspired. Any time you're browsing and come across something you love, tap the bookmark icon under the post, maybe even filter it into a specific collection, and now it's saved in a private place for anytime you want to refer to it.

Tap the bookmark icon to flag it, then save it to a collection to stay organized

Putting this feature to work

I use these bookmarks a ton. Here are my three favorites ways to put it to work for my brand:

Travel inspo

Well before going on any trip, I make an Instagram collection for that trip. For example, before heading to Italy, I made an "Italy" collection for my Instagram flags. From there I will spend a good amount of time searching through some of my favorite Instagram accounts, location tags, and hashtags to find content that could inspire my own trip. Not only can this help you find specific, cool locations, but it also helps you understand the colors, architecture, and scenery so you have a general sense of what you need to pack to create the most amazing content possible. It's a great way to prepare before actually arriving at a destination.

Outfits

I love to save the outfits I find for inspiration and even for shopping the products in the posts. Instagram has opened my eyes to so many new trends and inspiring designers whom I may never have discovered otherwise. You can also reach out to the designers you love, and who knows—maybe a collaboration will bubble up this way.

Where to eat

Who needs Yelp when a food-stagram speaks a million words? I love finding great new restaurants on Instagram, and I tend to have much better luck finding new eats this way than by scouring other apps, such as Yelp and OpenTable. Not only is it great for your taste buds, but you also get a much better idea whether a certain restaurant has the right vibe for your next food- or café-inspired photoshoot.

Some of my collections

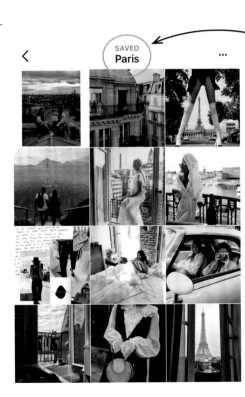

Photos posted by other accounts, used as inspiration for my Paris trip

This Paris collection gave me a sense of the many beige and golden colors of the city. I also loved seeing how other accounts captured themselves there with friends.

Find a flow

One day you're killing it, and the next day you're posting your fifth brunch photo in eight days. You're not in the flow, my friend. The flow is a magical place, where you're firing on all cylinders, snapping photos, nailing poses, and coming up with fresh content in your sleep. However, if you're not intentional with your time, you can easily slip out of this sweet spot, lose your creative spark, and start redoing stuff you've done often in the past. With a crafted content-production flow, you can ensure that your posts are always fresh and your feed has a better mix than your 9th grade mixtape.

What is a flow?

This is your standard workflow. It's a schedule outlining what types of post categories you're going to get and when so you don't end up shooting too much of the same thing, or not enough of another. If you're still trying to nail down post categories, flip to the beginning of this chapter.

My workflow

Below is my basic flow—not too crazy, totally manageable, and a great way to make sure I'm getting a good mix of content. However, just because I'm shooting my content in a flow like this doesn't mean I'm posting photos in a super organized way. Sometimes two fashion posts go next to each other, and that's okay. What matters is that you're getting a good mix of content in your backlog for future posts, while keeping it fresh on your feed.

Saturday & Sunday

On the **weekends**, my husband and I are always brunching, so we know we are going to get a brunch shot either on Saturday or Sunday.

We also have the most time to shoot on the weekends, so this is when we usually schedule our more intensely produced shoots so we can really nail them.

Monday

Mondays are generally pretty busy with meetings and administrative work, so if we shoot, we keep it simple and capture photos in our apartment or in the neighborhood.

Be flexible

Write down your own flow, but know that it will evolve and change. My flow is always a work in progress and isn't always perfect. Some weeks, I will have last minute collabs, spontaneous travel, or something crazy come up. That's totally cool...the flow can still flow; don't stress. I just find it good to have a decent blueprint to keep myself on track and focused.

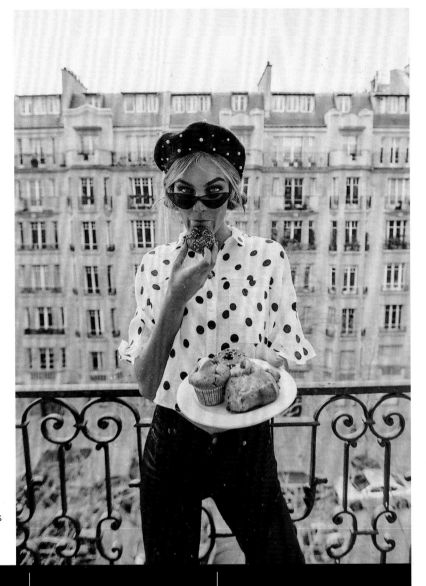

Paris making me Cray-sant. Thanks for a magical stay

Tuesday & Thursday

On **Tuesdays** and **Thursdays** we try to shoot more outfit-, fashion-, and editorial-oriented content.

Wednesday

On **Wednesdays,** my husband and I love to get shots together. Since we already spend most of our time together anyway, it's a natural fit.

Friday

On **Fridays** we don't always shoot. We'll catch up on editing, emails, or other projects we're working on. Then we try to enjoy Friday night.

Find your photographer

Selecting your photographer is a critically important, life-or-death situation. Okay, that is dramatic, but choosing your photographer is very important. This person needs to be someone you're comfortable posing in front of, bouncing ideas off of, and disagreeing with. Maybe this person actually is the person you marry (lucky me), but for many others, it is not. You will have to go through a bit of an audition process before you find the right one.

Tryouts

Make a list of photographers to contact, and look at some local Instagrammers whom you love for ideas. From there, come up with some shoot plans and reach out to line up some auditions. Once you find a photographer or two whom you really like, try a few more shoots with each of them to make sure the vibe is right and they can achieve the style you want. (See pages 60 and 61 for a discussion about establishing creative direction while on shoot.)

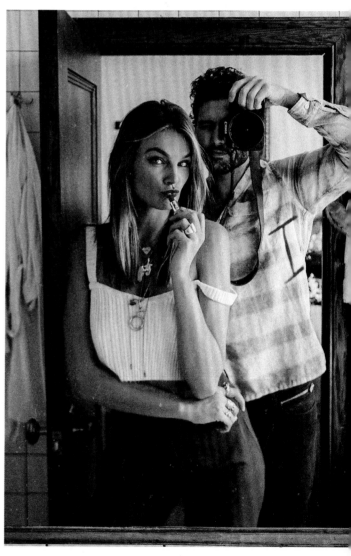

Be open

It can be totally nerve-racking to let someone into your creative mind, sharing so much as you set out on your Instagram journey, but it takes a team to make this Instagram thing real. You just need to jump in, put yourself out there, and find that photographer with whom you really click. Think of yourself as a creative director, setting out to hire your team who will put together unforgettable, epic shoots. You're a boss; make it happen.

Set expectations

Once you find "the one," negotiate some terms on how you want to work together going forward. It's important to have expectations set and schedules aligned so you're never lacking content. Some Instagrammers like to front-load their content creation, knocking out a bunch of shoots once or twice a week that will cover them for a while. Others spread it out and do it more real time. Figure out what works for each of your busy lives, and have a plan in place.

Edit your own photos

If you *do* want to pay a photographer to do your edits and retouching, then be absolutely certain you like their style. The way a photographer edits has a drastic impact on the style and tone of your feed. However, I highly recommend learning the basics of photo editing yourself. It will allow you to create and control your own aesthetic. Plus, it saves you a lot of money by not paying the photographer to also do edits and retouching.

Compensation

Make sure this is clearly outlined between you and your photographer before you start working together. If you have a relatively large following, you can compensate an up-and-coming photographer with photo credits and recommendations to help build their career. Do you need to give the photographer photo credit on every post? That's totally up to the two of you and should be discussed when defining compensation. I'm lucky I found an "Instagram Husband," but if you and your photographer are not married, here are some typical ways to compensate:

+ **Monthly retainer** If you find a photographer you absolutely love working with and want to form a team, paying them a monthly fee is a great way to do that. It establishes a clear legal relationship, and creates a feeling of empowerment and stability for both you and your photographer.

+ **Day rate** Some photographers work exclusively on a day rate. If that's the case, it's nice, and most cost effective, to load as much as you can into each day. Aim to work with them two or three times a week, and knock out all of your content.

+ **Per outfit rate** This method is popular among a lot of Instagrammers whom I know. A per-outfit rate allows your photographer to easily understand the scope of work for a shoot. Just keep in mind that it can quickly add up if you have several outfits you want to shoot in a day.

Instagram is a very collaborative place. Reach out to your favorite photographers and start an open dialogue. You'll learn a lot about what the going rate is and what your budget can accommodate.

List of things that are cute: 1. You

Location scouting

Location, location, location. Getting that perfect location can really make an Instagram photo pop, and it's definitely harder than it looks. For every cute café, colorful flower shop, or vintage car photo, there were hours that went into scouring Google maps and Pinterest, and wandering the streets. Finding locations is tricky, but it's your chance to become a private investigator, scouting around your town, the internet, and the world to discover that perfect Instagram-able spot.

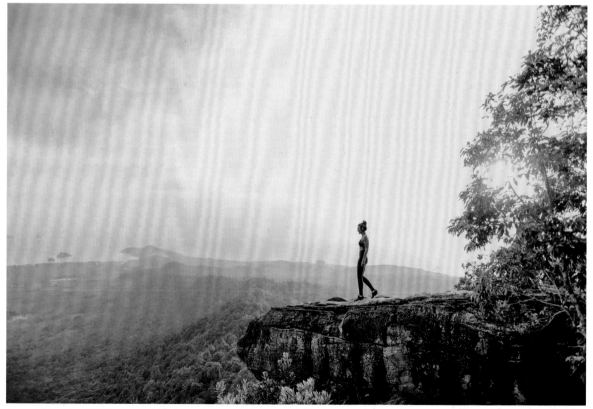

Dragons Tongue, *said to be a casual hike, was not so casual. It was all uphill,* real *hiking. We made it there right as the sun started to set, which was insanely beautiful. We found this spot by stumbling upon an Instagram location tag.*

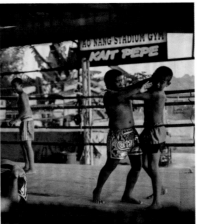

One evening Cole and I went on a walk down the street and stumbled into what might have been the most magical moment of this Thailand trip. In the middle of nowhere, as the sun was going down and turning everything to gold, we looked to our left and saw these young boys practicing Muay Thai underneath a tin roof. It felt like walking into a movie scene. The weights were old and rusty; the punching bags were so beautifully aged they looked like pieces of art. I took probably 4,000 pictures because I just couldn't get enough. Moments like these could be around every corner, whether you're exploring Thailand or your own neighborhood.

Use Instagram location tags

Instagram makes it super easy to search by location. Finally going on that trip to Tokyo? Search Tokyo on Instagram and start scrolling away. You'll likely stumble upon some killer spots and will understand the lay of the land before getting there and aimlessly wandering. Flag those photos for later, and start exploring once you get there.

Wander aimlessly

Remember when I said to save Instagram locations so you don't aimlessly wander? Well, it's not always a bad thing to hop in a car or walk around with your eyes peeled for that perfect spot. With an intentional photo mindset, your perspective completely shifts, and you will see your own town or vacation destination in a new way. Bring a camera or your photographer along, or pull up the map on your phone and save the location so you can find it later. A little aimless wandering is fun and can go a long way.

Ask a local

Nobody knows a town quite like a local. While they may not have killer photo destinations, per se, they'll know the hot spots in town that may just turn into that perfect, untapped Instagram location. Secret hikes, quaint restaurants, and breathtaking views are all tips a local may have up his or her sleeve if you just ask. So get off your phone, talk to some people for a bit, and you never know what you'll discover.

A dirty construction site can make a bomb backdrop.

LOCATION CHALLENGE

Sometimes I feel hopelessly out of ideas, thinking I will just stumble out the door and happen upon a magical location. Give yourself a challenge! I have found that sometimes, in a panic to get the shot done, I've made some of the ugliest or most boring locations come to life. Go ahead and give it a try, and pick a random spot. With a little determination to make it work and a touch of creativity, you just might surprise yourself.

Props

Props are a huge part of what can make or break an Instagram post. They're the cherry on top, the icing on the cake, the piece of the Instagram puzzle that can make a post go viral. I love finding props; I think it's a ton of fun to try to think of something unique and fun, and it stretches my creative muscles to do so. These are a few of my favorite tips and tricks to nailing the ultimate Insta-prop.

Ordinary to extraordinary

Take a quick inventory of your space and see if you have anything lying around that might make a good Insta-prop. You never know when an ordinary object might take your post to the next level. Some of my favorite props that I have found around the house include a skateboard, a watermelon, an old green glass water bottle, some lemons, red and white striped straws left over from a birthday party, and the list goes on. When styled or incorporated in the right way, an ordinary, everyday object can turn into a fun Insta-prop.

I love the spark of energy that props add to any photo. Don't limit yourself! A fun new prop is a great way to put your unique stamp on your posts.

Some of my faves

When hunting down props, make sure to keep in mind the overall theme of your shoot so that your props coordinate in an intentional way. Your prop can either match the rest of your shot perfectly, or they can be just quirky enough to provide a nice pop. Here are some of my favorite prop categories:

+ **Flowers** They always add such a beautiful pop to any photo. I love to include flowers from all ends of the spectrum: a simple bouquet from my local bodega, some wild flowers picked off the mountainside in my home state of Utah, freshly bloomed cherry blossoms in Central Park, or even a singular sunflower. I am always finding ways to include flowers in my photos. They are such a gorgeous and diverse accent to any post!

+ **Food** Does anyone not love food? I mean come on...who doesn't love seeing a fresh $1 slice of pepperoni pizza on their Instagram feed? Food is a great prop that connects with a massive range of people. It's also great when the space you're getting your food from has its own distinct vibe and texture. It's fun getting shots of delicious looking food in hole-in-the-wall Italian restaurants in NYC, or of big ice cream cones in front of charming little ice cream trucks on street corners. Food automatically adds a fun burst of energy to any post.

+ **Cars** Wowza, do I love me a vintage car. There's nothing better than cruising the streets of NYC and stumbling upon a sweet, red, 1970s Mercedes. Get the camera! A photoshoot is about to happen! There's something about a cool old car that gives any photo a vibe and a bit of nostalgia.

A massive flower is always a good choice

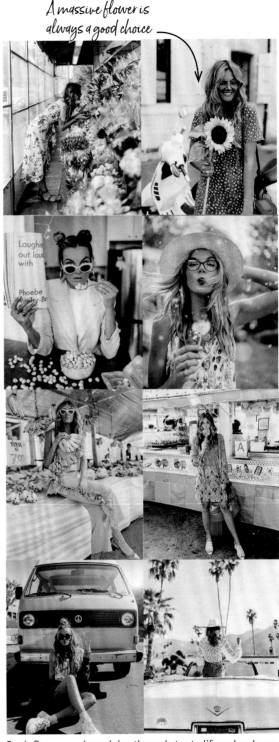

Food, flowers, and cars bring these photos to life and make me feel so much more natural and confident when posing.

Plan a photoshoot

Your mood board is fresh, you know the shots you want to get, your photographer is on board, and you're in the creative zone. This is when it all comes together, where you combine style expertise with your investigative location scouting and premier prop curation skills. While the spontaneous photoshoot is fun and exciting and sometimes works out well, it's much better to go into things with a plan. There's nothing worse than wasting hours of effort only to squander a shoot due to lack of planning.

Basket full of sunshine. Just kidding, mostly carbs I'm about to go eat.

1. Decide where

Careful scouting is an absolute must. Living in New York City, people often think you can just go outside and shoot anywhere, and it will be cool. This could not be more wrong, my friends. It's hard finding those perfectly Insta-worthy locations, and you definitely must know where you're going before gallivanting out into the world with camera in hand (see p54 for location-scouting tips). Think about the goal of your shoot and the outfit you have in mind so your location is the perfect complement.

2. Determine when

Choosing when to shoot is important for two key reasons: lighting and crowds. First, you want to make sure you are well aware of what time the sun rises and sets wherever you may be so you are getting your photos perfectly lit. Nothing is worse than missing the soft early morning glow only to battle harsh direct light, and it's even worse to have the sun set before you're ready—these scenarios are avoidable if you plan ahead.

Second, you must know when your shooting location will be extra busy and avoid that time at all costs. This is especially true of New York City, but it applies to anywhere. Dying to get that prime Eiffel Tower shot? You probably shouldn't go during tourist rush hour, or you'll battle crowds and end up incredibly frustrated. Try to shoot when your location will be more quiet and secluded so you can really get the shot you envision. It might be tough if you're not a morning person, but I often find early morning shoots are well worth the sleep sacrifice to get the perfect snaps.

3. Select props

I spend an immense amount of time curating props (see p56). Cool glass bottles, hats, bags—whatever it may be, I love to have an arsenal of props ready to roll whenever I need them. In my opinion, you can never have enough, as they really can make or break a shot. Be fully prepared ahead of time with any objects that could take your shot to the next level.

4. Style it up

Make sure everything is perfectly styled and ready to roll before photoshoot day arrives. Try everything on once more, check the fit, cut off any tags, and get in the zone. Don't end up wearing something that doesn't fit how you remember, or forgetting the iconic belt that really was going to make the shot.

Planning photoshoots is fun. When you have nailed down the perfect location, narrowed in on the ideal time, and are styled up with a killer outfit and prime props, get out there and get shooting!

Creative direction on shoot

You and your photographer need to get a feel for who is taking the creative reins while you're out shooting your content. It's important to establish who will be driving the creative direction of your shoots; you definitely don't want to butt heads with your photographer. Based on experience, I've seen the creative relationship between Instagrammer and photographer work three different ways.

1. You have 100% creative control of your shoots

If you want to go this route, make sure it is absolutely clear. It's hard when two strong creative forces collide. When more than one person wants control, it can end in disaster. This route is great when you have a crystal-clear sense of your style and direction and want to see it come to life. It's a lot more work on your part, coming up with every shoot, style, and prop, but having ultimate control can pay off in letting your vision shine through. It's empowering to know that the epic snaps you pulled off are entirely and authentically you.

2. You combine creative forces with your photographer

Maybe you find a photographer with a great eye and sense of creative direction, and the two of you can work as a team, achieving looks you just couldn't on your own. In this case, two minds are better than one. Just make sure your roles are defined so you're not stepping on each other's toes. Maybe you style the outfit and find the props, while your photographer nails down the location and type of posing. Communication is crucial in this kind of relationship.

3. Your photographer is the creative director, as well

This works well if you have a driven and remarkably creative photographer. This relationship can allow you to focus on outfits, attend meetings and events, and grow other parts of your business, while a massive amount of creative work is offloaded to someone else. The important point of this relationship is to make sure you align with your photographer's vision and are okay giving up some creative control.

Friends with benefits

Team up with some of your friends to bring a shoot together; it's hard to pull off all of this stuff by yourself. Find someone you can run outfits by, bounce ideas off of, and brainstorm with so that the creative juices flow. My husband Cole and I work together as a team, and we're constantly thinking through new photo ideas and focusing in on the creative direction for upcoming shoots. Having a trusted confidant, or a few, goes a long way in helping you take your shoots to their full potential. Let your friends in on what you have going on, and it could lead somewhere beautiful.

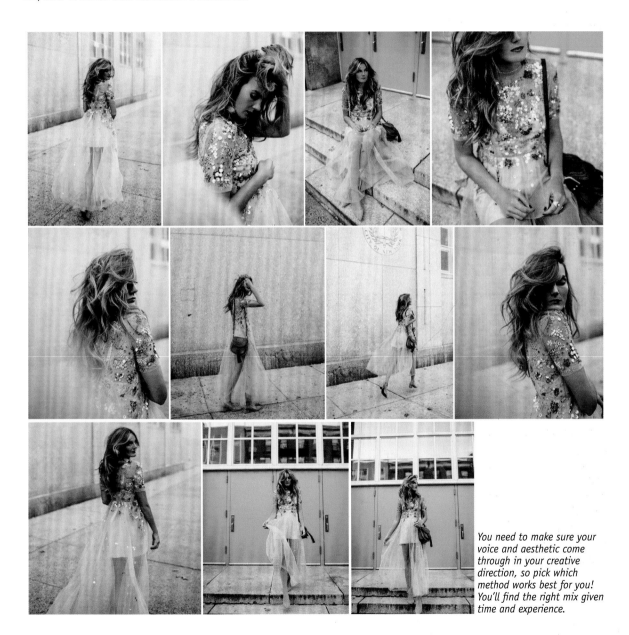

You need to make sure your voice and aesthetic come through in your creative direction, so pick which method works best for you! You'll find the right mix given time and experience.

First impressions

When you start gaining traction on your Instagram and accounts are linking to your profile—brands are reposting you, and maybe even a follower shouts you out on their Story because you are their crush of the week—remember that your grid makes the biggest first impression. The first thing people see when they click on your page is the overall feel of your feed. You hope they stick around and click on individual posts, but in case they don't, you want your grid to give them the feels. Make your bio unique, your grid aesthetically pleasing, and think about the type of first impression you want to make so people will want to stay a while.

A pretty grid is key

Think of your grid kind of like a Tinder profile picture. People are going to stumble onto your feed, see how nice your grid looks, and decide to follow you from there...or not. Most people don't spend too much time going into your individual posts before tapping that Follow button. It's important to make the first impression the best version of you. Space out posts with colors and composition, have some fun, and the followers will start rolling in.

Have fun

Yes, you should be focused on cultivating your first impression; however, if creating that perfect Instagram feed is causing you a headache and preventing you from moving forward with certain shoots and just having fun with it, then bail on the perfection and just have some fun! I am definitely prone to overthinking my feed sometimes. During these times, I find myself holding back and not posting things I otherwise think are awesome. If you're ever in a similar situation, opt to have fun and post what you love and want to post. I find that once I start doing that again, my feed will pick back up and naturally start to fall into place.

Shift your perspective and evaluate your grid as an outsider. However, don't try to force perfection!

Pretty grid pointers

 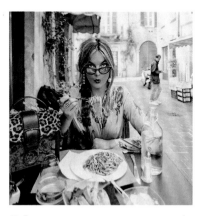

Poses

You want to make sure you're not putting too many photos together where you are posed or composed exactly the same way. If you don't mix up your posing, your feed can look clunky or cluttered. For example, you would not want to post two photos in a row from the waist up with your face turned to the right. It's easy to get too comfortable with a certain type of photo or pose, so make a conscious effort to mix it up. Your feed will look cleaner and more engaging.

Spacer photos

There is something aesthetically pleasing about breaking up your Instagram feed from just seeing your face in every photo. There are many ways to do this: showing close-up fashion details, mixing in scenery shots, snapping food pictures, taking group shots with friends, cropping uniquely, or getting photos where you're in the distance. Spacer photos create some breathing room and flow in your feed. When you're shooting, make sure to get those "spacer vibe" shots. They'll come in handy as you're planning out your grid.

Colors

It's important to keep an overall consistent color scheme for your grid. You will achieve this by sticking to the same few filters or Lightroom presets. Even if you're taking your photos in different lighting situations and locations and wearing different-colored outfits, as long as you are remaining consistent with your editing tools, then the overall color scheme will look cohesive and pleasing to the eye. This can help draw people in so they tap that Follow button. I go into more depth about filters on pages 68 to 69, and 99.

tezzamb ✓ Follow ▾ ···

3,033 posts 482k followers 1,885 following

Tezza 📍NYC Musician • Creative Director • Stylist • Traveler
Taste the rainbow 🌈 @thebanddoe Shop photo presets
/Collage Kit 🖌 @shoptezza
www.shoptezza.com

The simple snippets in my bio reflect my personality and story

This pose is totally different from other recent poses

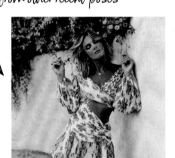

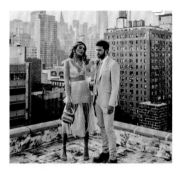

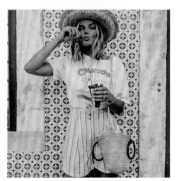

This spacer shot of me at a distance gives my grid some breathing room

Carefully craft your bio

Use these words to tell the world what you're all about (see p31 for more specifics). Take a step back to look at the package of your grid and bio as one. Do they tell a consistent story? Is there something you should write in your bio that can help the audience make sense of your individual posts? For example, if your feed is full of interior photos of your house, you might want to explain the broader story in your bio: "Join me as we transform a battered barn into our home, one DIY at a time." The bottom line is that you must let your personality come through—whether straightforward, or just plain witty and funny. The bio is part of the first impression that you present.

Perfect planning makes perfect

It always comes back to the grid! Lucky for us, there are some amazing people in the world who have built some fantastic grid-planning apps, and some of them are even free, helping you perfect the vibe of your feed. Here are some of my favorites, which will help you take your grid to the next level.

UNUM

I use this all the time to plan my Instagram grid. It's super easy to load in a bunch of photos and drag them around in different arrangements before actually posting live to Instagram. It helps me nail my feed aesthetic in advance.

Preview

Not only can you lay out your Instagram feed in advance here, but you can also edit photos and dig into handy analytics. It's a one-stop shop.

Planoly

This one is similar to UNUM in its planning capabilities, but it's also packed with analytics and discovery tools.

Prime for Instagram

Now that your grid is all planned out and feeling really good, use this app to actually schedule your posts to go live at peak times, in the order that you want.

Focusing on your grid as a whole defines your broader story and aesthetic. A refined grid helps newcomers understand your story right away. Grid planning is another piece to the Instagram puzzle, and it really makes a difference.

Storytelling through your grid

As much as I enjoy thinking about and creating individual Instagram posts, I also love managing my Instagram grid as a whole. It's my personal magazine—my storybook—and the creative process of piecing everything together to achieve one beautiful grid is a blast. While you can post whatever, whenever, and have a haphazard type of grid, I like to be more curated and thoughtful when going about it. The key is to tell a story.

Be chronological

The best accounts take you with them on a journey—it's fun to get absorbed in the experience. Try to generally use a narrative format through your feed by including a beginning, middle, and end. Your followers weren't on that red eye with you, so tell them where you are in a Story, or give them a teaser with a suitcase flat lay. Obviously show off your adventures in the middle of the story, and then give some closure as you move on to the next big (or little) thing.

It's important to weave a cohesive story with an aesthetic, a flow, and a feel. This has happened to me before: you're on a trip, creating posts and sharing experiences, when suddenly you stumble upon a killer photo you wanted to post from weeks ago, but you forgot. It's tempting to just post that photo right away, but hold off! Keep the narrative going on your current trip, and post that photo when you're back home. I'm not saying you must be perfectly chronological; it's okay to post a photo from the first day of your trip on the third day you're there. As long as your posts have a story or theme, go for it.

Create look books

Some settings or outfits are just too amazing to only post one photo. In that case, it's totally fun to create a multi-photo "look book," and post a few photos from that specific shoot or outfit over time. Take your followers on a journey, and weave a photo-narrative similar to how *Vogue* creates a spread, or to how your favorite brand creates a world through a look book. It's a great way to take a more long-form approach to your posting and curate a look book of your own.

Focus on the nine most recent posts

When planning your grid's visual story, you really just need to consider your nine newest posts. Those first nine form a nice block right at the top of your profile page, and they're what create a first impression. Keep those super tight; have them build off each other and tell a story together. Thoughtfully transition between sets of posts so that the aesthetic and content of consecutive posts don't create jarring contrast.

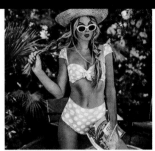

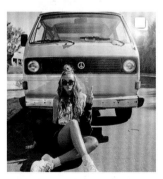

Tezza does Coachella. I brought my followers with me, showing off the landscape of the whole trip. This experience was so full of photo-worthy experiences that it spanned more than nine posts.

Storytelling through your grid 67

Your recognizable aesthetic

Remember that first impressions are everything. I pay close attention to what makes me want to follow someone when I click over to their profile. Narrowed down to one thing, it would be that they have a beautiful, distinct grid aesthetic. In an instant, I can recognize when someone's feed is carefully curated, and I am immediately drawn into following them without even clicking on an individual post.

Be consistent with filters

This is the number one rule when creating a curated, beautiful grid. Consistent filters are so important when distinguishing your brand—they elevate it to something that is recognizable in an instant, which will in turn make it easy for people to remember you, talk about you, and discover you. People will begin to intuitively recognize your aesthetic and connect it to you as they're scrolling through their feed. Do your best to limit your filter choices between one to three selections in rotation. While it's easy to go filter crazy with all of the choices available to you, it's crucial to focus in on the ones that work best for your style and brand.

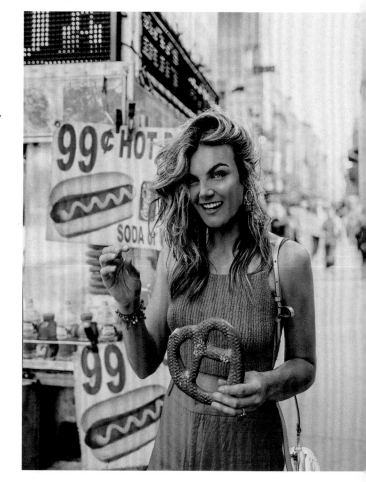

 Keep your friends close and your snacks closer. New blog post with my favorite summer jewelry @kendrascott

Get grid fancy

While you can take a more freestyle approach if you want, there are a million ways to layout your Instagram grid to put your own creative stamp on it. Here are some popular methods of grid planning to consider when thinking through your layout. Don't limit yourself to just these methods; think outside the box, and come up with your own crazy-cool, unique grid layout.

+ **Use borders** I have come across grids that strategically use borders to create a unique aesthetic. This is achieved by adding borders to your photos with one of the various photo-editing apps that allow it (such as VSCO and Afterlight). It's a nice way to create some extra clean white space between photos. Even use colored borders for something a little funkier.

+ **Create a checkerboard** Think of your grid as a checkerboard. Alternate your posts between two very distinct aesthetics. For example, every time you post a photo, the next post could be a quote on a solid background. Your grid will look like a checkerboard and provide a unique perspective and story to keep your followers engaged.

+ **Make a puzzle** I have also seen feeds where each post is a piece of a puzzle, and to understand the whole image you have to bounce on over to their feed to see it. While this type of tactic can create a beautiful profile grid, it can be slightly annoying to followers who don't want to see just a little piece of a puzzle in their timelines. To pull this off, you need to use photo-editing software such as Photoshop, and cut your image into as many as squares as you'd like to make your puzzle. From there, just post each square individually and in the right order, and bam!—your feed will be one big art piece rather than a collection of individual posts.

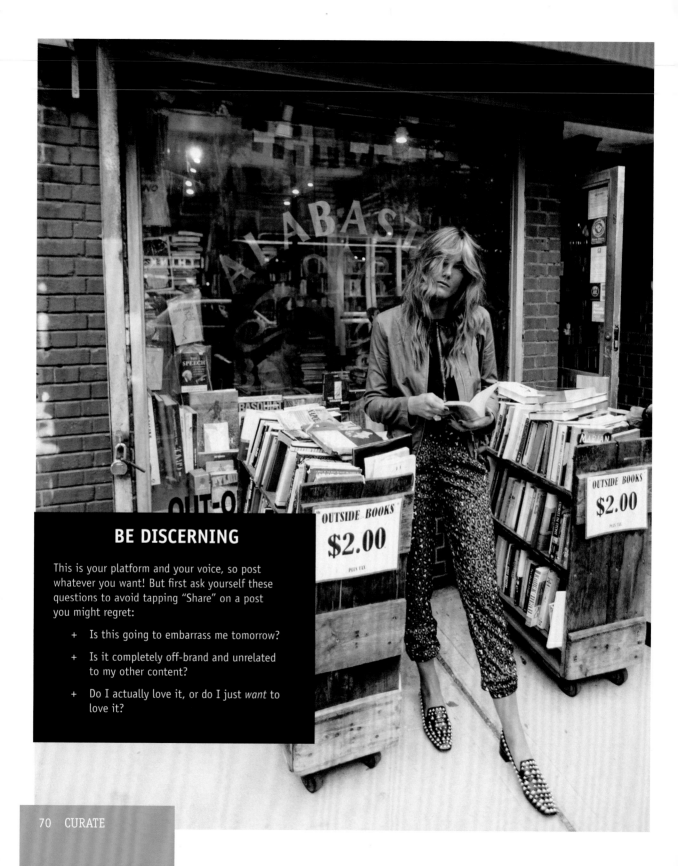

BE DISCERNING

This is your platform and your voice, so post whatever you want! But first ask yourself these questions to avoid tapping "Share" on a post you might regret:

+ Is this going to embarrass me tomorrow?

+ Is it completely off-brand and unrelated to my other content?

+ Do I actually love it, or do I just *want* to love it?

Post-worthy?

Once you get your Instagram rolling and you become a pro both in front of and behind the camera, you will start to notice you often have several photos you really like. Deciding which photos to post and which to trash can sometimes be daunting.

Ask your circle of trust

Find your circle of trust, the people you can count on. Your circle should be full of people similar to your followers. For example if your following is 80 percent female, well...sending your photos to only males for approval might not be the best idea. Find friends who have opinions and are honest with you. You will start to notice trends in what people are drawn to when helping you choose. It could be a good way to learn what you are doing best in your photos, something you should continue to cultivate.

Think like a music album

Not every picture you post will be the best photo you have ever taken, but think about it like your favorite music album: you don't always go head-over-heels for every single song. Some grow on you, and others are on the album to make the amazing ones stand out. The most important thing to remember is that you love what you're sharing, and you're sharing it because it represents you.

When to toss it out

I have had a few photos that I look back on and wonder why I thought they were the best photos to post. (Don't forget that you can always delete or archive photos so that they're no longer visible to the public.) I realized a theme in the ones that usually don't or shouldn't make the cut:

+ **Too busy** If there is so much going on that the eye doesn't know where to look, people usually scroll past those.

+ **Too far away** While a scenery shot is pretty, it has to be done just right. Make sure to have a focus in the photo, and use helpful photography rules like the rule of thirds (see p82). These make a world of difference in helping the more zoomed out shots still be successful.

+ **Too pose-y** Okay, this is all dependent on how you have branded yourself. I know you will find what works for you, but for me, I'm not a model, and people don't like it when I try to be.

Think like a magazine

Once you feel you have a brand of your own, you're collaborating with other brands, sharing products you love, or traveling to corners of the world, remember—you have become your own magazine. You have an audience, a brand, and a voice, and you are the editor-in-chief. Having this magazine mindset will help when deciding whether or not you should take certain jobs or post certain photos. *Vogue* doesn't let just any brand advertise on their pages or let any photographer shoot for their spreads. You should be the same.

Your look, your feel, your message

When you think like a magazine, you will start to curate content that contributes to a broader message, and where each element serves a purpose greater than itself. If you could print out all of your photos, captions, and collaborations, and bind them into a magazine, what kind of story would they tell? There are so many crucial facets to Instagram for which you need to create content, and it's important that your voice and brand are consistent through all of them.

Each of these are a part of your personal magazine, so make sure they fit your mission:

+ Photo and video posts

+ Captions

+ Stories

+ Live

+ Highlights

+ DMs

+ Comments

When I flip through some of my favorite magazines, I am in awe of the cover, the spreads, the stories, and even the advertisements. Everything works so well as one consistent, beautiful package, and you can clearly see a defined voice throughout. I strive to make my Instagram account feel the same.

Let it evolve

All this being said, remember that your brand is subject to change and grow. This growth is actually a beautiful thing, so please don't view change as a failure. The hope with your Instagram brand is that it *does* grow and is something you can have and use for a long period of time as you develop as a person. You might start as a young fashion-driven woman who travels the world, but then find yourself turning into a mommy blogger, or a fitness guru who finds a love for fashion after posting about some of your new outfits and realizing your following is really into it. This change is good and something that your audience will love and understand. Just know that the brands you work with will change, too.

Take time to travel

Being in the same space every day and trying to come up with new content ideas can sometimes feel impossible. Find ways to travel—take mini road trips, big road trips, or train rides. Whatever it is, get up and move. It's a great tool for keeping your following engaged and letting them see you in a new space.

Any trip will do

Of course big international trips are a blast, but keeping those up regularly isn't always realistic, especially when just starting out. Go on a mini road trip instead. Head to a cool town near you for the weekend, pack up a car with some friends and some snacks, and hit the road. It doesn't have to be anything crazy. Just getting yourself out of the norm and into a new space can inspire new content and get your followers interested and excited.

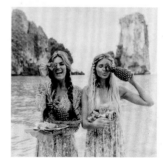

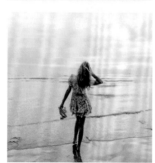

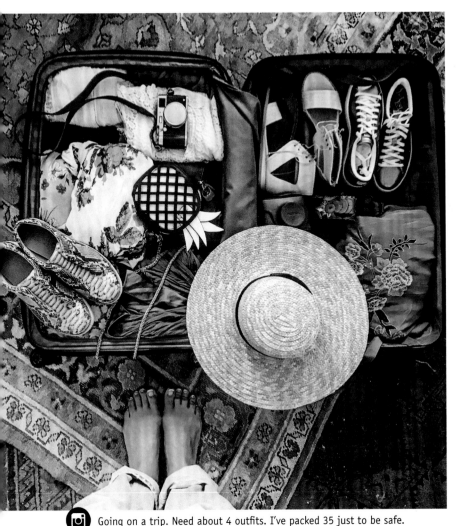

Plan ahead

It's easy to think you will arrive at your vacation destination and automatically start snapping amazing photos just because it's somewhere new and exotic. I'm sad to say that is not always the case. When you're somewhere new on vacation and have limited time, it's crucial to plan ahead and have some spots and ideas in mind for where and what you want to shoot.

Start a Pinterest board or Instagram collection well in advance of your trip and curate inspiration. Hit up friends or acquaintances on Instagram who have been there in the past. Most people will be friendly and will share handy tips. Instagram also has an excellent geosearch feature where you can search by location. This is super helpful for finding cool spots and travel inspiration before setting foot in an exciting foreign land.

Going on a trip. Need about 4 outfits. I've packed 35 just to be safe.

Hit your Stories hard

It can definitely be draining to document your travels and get killer posts for everything you're doing, but using Stories is a great way to take your followers on your trip with you without as much effort as putting together a curated post. Show a quick video of an amazing view, get a shot of a boat ride, or even a quick pic of some new and interesting food. All of these moments may be too tricky to formally post, but you can always give your followers a taste of the action with some quick and candid Story posts.

Curate who you follow

It's crazy how much the media you consume affects you, especially your Insta-feed. At one time I was following so many meme accounts I started having conversations in meme format. Something had to change. I unfollowed all the meme and cluttered accounts I was following and stuck with only accounts I found beautiful and inspiring. From then on, I started getting so much more joy out of using Instagram. Curate who you choose to follow as much as you curate your feed. Don't be afraid to give your favorite accounts some praise; many of these people are hoping to engage with their followers.

Follow your faves

I have found some amazingly talented people on Instagram who have inspired me to create some of my best work. Luckily, Instagram has excellent Explore features (see p27) that help you find the latest and greatest people to follow. Whenever you follow someone cool, Instagram immediately presents you with similar accounts, called "Suggestions for You." Click around on those accounts because it is a great way to stumble upon fresh content and incredible people. I also find some pretty great stuff browsing around the Explore tab (the magnifying glass icon). Some people get stingy with how many people they follow, preferring to keep it small, but I am always adding new people to my follow list.

Be a conscious consumer

Rather than mindlessly scrolling through your Instagram feed, try to be very conscious of what you are consuming and who you are following. Granted, Instagram is a fun way to waste some time catching up with friends or just simply browsing, but if you choose to be aware and mindful of what is going on in your feed, you may stumble upon some fresh inspiration, learn something new, or even connect with a fellow Instagrammer. Curating your feed can have profound effects on the way you think about Instagram.

Get involved

Yes, it's a social platform—did you forget? Commenting on posts and engaging with other accounts is just as important as posting and sharing your own content. You can't be only a taker in the 'gram world; you have to be willing to give back as a part of the community. Whether that means writing on your friends' posts, responding to your followers' DMs, or leaving meaningful comments, getting involved with your fellow creators can forge new relationships, expand your network, and enhance your Insta-experience.

Avoid burnout

(Cue Rihanna.) Work, work, work, work, work, work. Phew, sometimes this Instagram grind can wear me down. Don't get me wrong, I love the opportunity to share my story and be my own boss, but when work and life are so intertwined, it can really take a toll. It's important to avoid getting burnt out, otherwise you'll lose that spark that made you get started in the first place, and your photos can start to take a dip.

What is burnout?

Are you not feeling like yourself? Your love and passion for what you do is dwindling, and you just kind of feel like popping a bowl of popcorn, firing up Netflix, and taking the week off on a Monday at ten in the morning. This, my friends, is classic burnout syndrome. It's important to be honest with yourself when you're experiencing this feeling. Realize it's okay, but then take action to rekindle the flames and get back to world domination.

What is it about your own space and your own bed that just feels so right? Throw on some pajamas and have a day in. Take time for yourself.

Staycation!

Ways to stay motivated

Burnout is real. Believe me, I've been there before. There's a lot of pressure to constantly be creative and to one-up yourself with every post. Don't let it take you down for the count. Take some time for yourself, and bounce back with a whole new energy and perspective.

1. Treat yo'self.
Take a spa day, go to the pool, read a book, do a Sudoku puzzle, or just plain chill. Sometimes you need a break, and that's okay. Ignoring your feelings of burnout can be dangerous. Have some quality *you* time, take a deep breath, and hit the reset button. The world will be there tomorrow, and it won't know what hit it when your post-burnout self is ready for action.

2. Take a real vacation.
With the pressure to always create content, a "vacation" can really just feel like "working extra hard in a foreign land." When I take a "vacation," sometimes I get home and realize how much I need a vacation from that vacation because I'm so exhausted. It's important to unplug for a bit. A good strategy for vacations is to spend the first day or two getting some killer content, and then spend the rest of your trip chilling, while casually posting the treasure trove of good stuff you got at the beginning. You won't totally lose the posting momentum, and you won't burn out, either.

3. Try something totally new.
Posting the same old stuff can really wear me down. When I feel this way, I try to create something totally new to reinvigorate my creative energy and to inspire my feed into the future. Take photos like you never have before. Don't worry about what you've done in the past or how many likes it will get; just try totally new things because you want to.

Create

Visual storytelling for every aspect of your life:
essentials, tips, inspiration, content ideas,
and dos and don'ts

Photography pointers

Time to actually create some magic. Sharpening your photography skills is essential. No matter if you're shooting with a fancy DSLR camera or your smartphone, the same principles apply. I had years of initial experience as a fine arts photographer before applying the skills I learned to my Instagram career, and it's helped immensely.

1. Employ rule of thirds

This simple composition technique keeps photos balanced. The basic idea is to imagine splitting your image into thirds, both horizontally and vertically, so you have nine parts. Theoretically, if you place points of interest in the intersections or along the lines of the grid, your photo becomes more balanced and visually pleasing. Science, right?

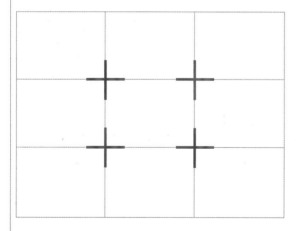

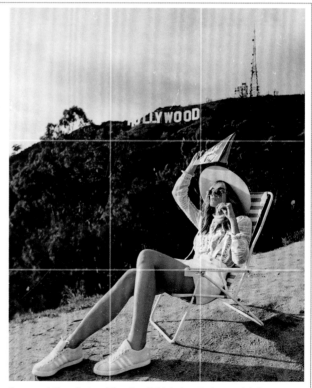

I cropped the photo with rule of thirds in mind, creating interest around my face and my shoes, and allowing negative space.

2. Crop naturally

This is a simple one, but so, so important. Don't crop your photos weirdly! What I mean by that is: don't awkwardly crop off your feet, don't crop straight through your knees, and don't oddly crop above the waist. If you're looking a little amputated, like your feet got cut off in a terrible accident or something, that probably means you weirdly cropped your photo. Try to show your full body, crop just above or below the waist, or just above the knees.

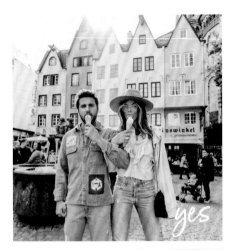

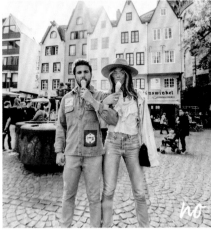

In the first photo, the crop just above the knees looks natural. In the second photo, our feet look unfortunately amputated.

3. Don't get too busy

Avoid color and pattern overdose. Let your photos pop, fill them with props and color, but don't let them get too busy or cluttered. You want people to be able to clearly identify and relate to the subject and not get lost in a mess. Keep it simple. Some of the most successful and amazing photos in the world are extremely simple. The more patterns and colors in your image, the more difficult it can be to achieve the powerful photo you are after. Of course, there is a time and place for busy and "extra," but if you are just jumping in, I recommend starting simple. Try to stick to two main colors in your image...it's easiest on the eyes.

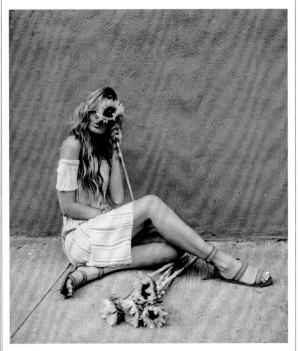

This solid orange wall was perfect for a punch of color. The simple background draws the eyes right to the beautiful sunflowers, which are color coordinated with everything else in the shot.

4. What is that growing out of your head?

This is another simple one, but also very important. Make sure you are positioned in the scene with awareness of your background; you don't want something to look like it's coming out of your head! Street signs, tree branches, or random lines coming out from your head can be very distracting.

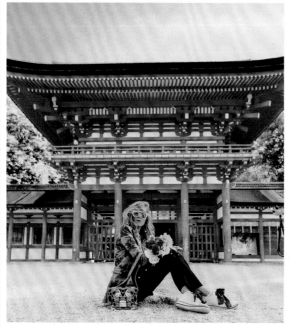

Notice how I'm shifted over so the column isn't emerging from the crown of my head.

5. Focus on the eyes

If there is a person in the image, then 99 times out of 100, their eyes should be in focus. When a person looks at another person, the main thing they look at is the eyes. As a general rule, focusing on the eyes and keeping the detail sharp will help all the other tips properly fall in to place.

The strong focus on my left eye draws the viewer in, creating a connection.

6. Explore perspectives

If you take a second to look at some of your favorite photographs, you might start to notice that perspective is everything, a common theme drawing you in. Move your feet around, explore your subject, and find the most vibrant view. When photographing people, you'll notice your subject will look more dynamic if you crouch down to capture the photo, giving the subject a grand presence. When shooting from above, you can minimize your subject and lose the wow factor.

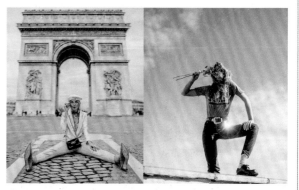

The lower perspective makes me look longer and more captivating, while making the architecture more awe-inspiring.

7. Use leading lines

You can strategically use lines to lead the viewer's eyes into the photo and straight to the subject. For example, roads, fences, shorelines, aisles, or window panes can all create depth, perspective, and a visual journey for the viewer directly to the subject.

All waterfalls point to us. The cascading lines lead the eyes directly to our romantic little scene.

8. Try burst mode

Also called continuous shooting, this mode allows you to capture frame after frame in an unbroken flow to make the action come to life. It's a great choice if you want to capture movement so that you get the perfect, in-focus moment.

Burst mode lets me capture the dynamic hair billow, the flattering sway of fabric, and the in-between moments.

9. Take advantage of depth of field

Play around with which parts of the image you have in focus to draw attention to a certain subject. To adjust your depth of field, use the aperture settings. A wider aperture (e.g., f/1.4) brings a shallow depth of field, which is great for isolating a subject from its surroundings. Conversely, a tighter aperture (e.g., f/22) gives a deeper depth of field, allowing more of the image to be in focus.

Blowing out the collage of photos in the background makes the photo less busy so that each mouthwatering detail of the pancake stack jumps out.

MAKE MISTAKES

There are endless rules and principles to photography, but some of the best photographs are made by accident. Learn from your own mistakes. When jumping in, don't be too afraid to play around and try things. It's the best way to learn what you like and refine your expertise.

iPhone camera tips and tricks

Most smartphone cameras have incredible features and astounding quality. It's amazing that you have a high-powered, high-quality, beautiful camera sitting in your pocket at all times, ready for you to unleash your creative energy to the world. For years, I've been an iPhone user, and I've picked up some tricks to make the most high-quality photos possible with its particular lens and interface. Other smartphone brands offer similar capabilities.

Tap to focus

This is a simple one, but oh so crucial. There is nothing more disappointing than snapping a bunch of photos only to realize they are all a little soft, and your subject is out of focus. Always remember simply to tap on the subject you are trying to capture. As you tap on your iPhone screen, you will see a square appear—this is your focal point. The iPhone will automatically adjust its focus based on where you have tapped, helping you to capture crystal-clear photos.

To lock your focus and exposure, tap and hold on your focal point until you see an "AE/AF Lock" banner appear at the top of the screen.

Exposure adjust

What a beautiful sunset! OMG this is my favorite performer at Coachella! This latte looks amazing! We've all had these picture-worthy moments in not so picture-worthy lighting. The key to getting the best picture out of these situations is simply to adjust the exposure on your iPhone camera before taking the shot. To do this, tap on the screen, keep your finger held down, then either drag upward to increase exposure (brightening the photo), or drag downward (darkening the photo). Sometimes the iPhone just won't be able to do everything automatically, and you need to take matters into your own hands. Luckily it's easy to pull off perfect exposure with this simple trick.

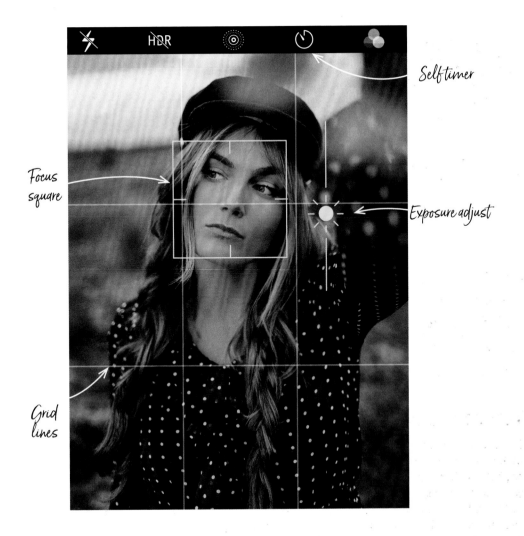

Self timer

Focus
square

Exposure adjust

Grid
lines

Self timer

I love the self-timer feature on the iPhone and have used it for years. When I was just starting out on Instagram, before I had a photographer with me at all times, it was one of my go-to photo-taking methods. It's super easy to lean your phone up on a shelf, or any flat surface, and the camera does a great job at figuring out where to focus all on its own. To activate self-timer mode, just tap on the little icon that looks like a clock. You can choose how long you would like before the picture is taken, giving you ample time to get into position.

Grid

Taking photos with the grid overlay is super handy. It helps you make sure your photos are expertly composed, following that nice rule of thirds (see p82), and aligned and straight so you don't have to spend time correcting later. You can toggle the grid on and off, so go ahead and give it a shot next time you're taking photos on your iPhone to see if it helps. Enabling this feature isn't super obvious; you actually have to go to your Settings app, then tap on the Camera option—there you will see a switch to enable the grid.

Achieve the best lighting

Understanding and using appropriate lighting is the number one key to photography. After all, photography is, by definition, the act of capturing and recording light. And yes, I just pulled some Bill Nye the Science Guy stuff right there. Many of the same principles apply whether you're shooting on a smartphone or a DSLR, so the tips I give for one can carry over to the other. There are a four lighting situations you should learn to work with.

Hard light

Hard light is usually direct and comes from a single, concentrated light source. It will make the shadows in your photo defined, and will look more harsh and pop-y. Think of shooting at noon in Arizona on a summer day with no clouds. The light on your subject will be super bright and defined, and the image will have sharp contrast and texture.

Soft light

This is created when there are multiple light sources, or when your light is diffused or reflected so it's not as direct. It hits your subject from many different angles. Think of photos taken early in the day or at sunset—a.k.a. *golden hour*. Soft light is generally warmer and has more of a glow, and colors and shadows will be spread more evenly.

Natural light

This is light that comes from the sun, and it's always variable. It's important to learn to set up your shots according to different natural lighting situations, adapting to the time of day and weather. I love shooting in natural light, as it allows me to shoot pretty much anywhere and everywhere with nothing but my camera—no need for professional lighting equipment or a flash. I usually try to shoot during golden hour, which is just before the sun is fully up or just before sunset. The light from the sun at this time will be low to the ground and not as harsh on your subjects, creating a nice, soft light. I shoot almost exclusively in natural light settings since I'm always on the go, and I love the feel of naturally lit photography. It definitely has a lifestyle feel.

Artificial light

This refers to lighting produced by any man-made source. Think light bulbs, flashes, lamps, etc. Since artificial light is usually more focused and direct from a single source, it tends to produce harsher shadows and contrast, and it can be more difficult to get flattering photos of people. For that reason, I tend not to shoot in artificial light as much. There are professional, artificial lighting setups that can produce really beautiful photos of people, but the setups do tend to be bulkier and more expensive, making it less practical to have on hand when creating photos on the go.

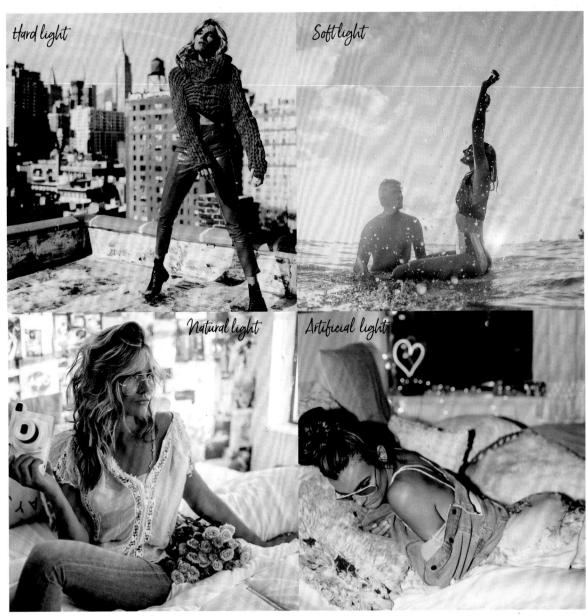

Hard light

Soft light

Natural light

Artificial light

Where to start

For those just learning the ropes of photography, I recommend shooting in soft, natural light at sunrise or sunset, when the light is evenly diffused over your subject. For vibrant, more detailed photos, you can take a swing at shooting in direct, hard light. You can create some really nice photos this way, but it's just a bit harder to work with. Finally, shooting in artificial light brings its own set of challenges, but with some tweaks to your white balance and shooting in RAW to enable full editing control, it is doable and opens up a new world of the types of photos you can capture.

Your camera's lighting settings

The settings you can tweak on a DSLR are endless. With that said, if I were to distill the thousands of settings on my Canon down to the essentials for good lighting, they would be shutter speed, ISO, and aperture. It takes a lot of practice and experimentation to figure out what is best for the types of photos you want to create, but it is absolutely worth it. Doing so gives you full creative control.

Shutter speed

Your camera has a shutter in front of the image sensor, and the longer it is left open, the more light will be let into the sensor, creating a more exposed and lighter image. If your shutter speed is low (left open longer), you will be able to shoot in a darker setting because you will be letting more light reach the sensor. However, you will not be able to sharply capture a fast-moving subject. If your shutter speed is super high (not left open long), you will be able to sharply capture a fast-moving subject, but it will also make your photo less exposed and darker.

ISO

This measures how sensitive you want your camera sensor to be to light. The higher the number, the more sensitive. Upping your ISO is handy when you want to maintain a high shutter speed in darker settings, but upping it too far does have drawbacks. As your ISO setting gets higher, the noise and grain in your photo will also increase. Generally, I keep my ISO as low as possible, and I only up it further if I'm shooting in a darker setting without enough natural light.

Aperture

The aperture is the hole within your lens that controls how much light travels through into your camera. I like to think of it as the pupil—it expands or shrinks to let more or less light in. Aperture is measured in f-stops, and you will see it specified on your camera as something like this: f/1.4, f/2.8, etc. It may be counterintuitive, but the smaller the number, the larger the aperture letting light into your camera. The more light you let into your camera, the more exposed the image.

Aperture also determines the depth of field for your photos—the amount of your photo that will be in focus from front to back—which is critical in creating your particular photographic aesthetic (see p85). The smaller the f-stop number, the less that will be in focus, and the more of your photo outside of the focal point that will be blurry. I tend to keep my f-stop pretty low since I like to create that soft, blurry effect around the focal point of my photos. With that being said, sometimes there is a beautiful view behind me that needs to be brought into focus a bit more, so I'll increase my f-stop.

A note about shadows

With great shadows comes great responsibility. When shadows are used correctly, they can create amazing texture or pattern in your photos. If they're misused, they can just look flat-out bad. If part of your body or face is in the light and the other part isn't, it can be very distracting. Your photos also become hard to edit if there are weird shadows. My advice is to light your photos evenly when starting out as a novice. As you become more comfortable with your photography skills, start to play with shadows and see if you can make some sweet shadow magic.

SMARTPHONE LIGHTING

When you shoot on a smartphone, you lose a lot of the control that a DSLR offers, but you gain portability and convenience. I do have to think about lighting differently when snapping with my iPhone because of its limitations.

+ **Create even lighting.** Since your phone is trying to handle so much of the lighting settings automatically for you, it is so important to make sure your photo is evenly lit. Try to position everything either entirely in the light, or entirely in the shade, to limit the amount of shadows.

+ **Manually adjust exposure.** Sometimes your smartphone needs a bit of help to increase or decrease the exposure. On an iPhone, you can easily adjust it yourself by tapping and dragging up and down (see p86).

Occupation: Aspiring Beam of Light

Mastering light is the key to creating a beautiful, professional, follow-worthy aesthetic.

Posing

Oh, don't mind me. I'm just in the middle of New York City, surrounded by hordes of people, in an over-the-top outfit with a bouquet of flowers fit for Queen Elizabeth, dancing around like Mick Jagger and David Bowie in the "Dancing In The Street" music video. Do I feel awkward? Yes. Is it worth it? Absolutely.

Just do it

Posing is awkward, nerve-racking, and can make you feel like a bit of a fool, but it is totally worthwhile. Props and movement are important, and if there is one thing I have learned over the years, it's not to care what other people think. Most of those people giving you funny looks as you're pulling off your epic pose will be the same people losing their mind at how amazing your photo is when they see it on Instagram. Just do you!

Move it

If you only remember one thing about posing, it should be this: move it or lose it. Movement is key to making your photos have that organic, in-the-moment feeling that I love. Getting a little dress ruffle, some hair flip, and laughter can turn an ordinary photo into a little square of magic on someone's feed. When you're out there making it happen like I know you will, keep it moving and let your photographer capture those in-between moments that really make it special.

Props help

Notice how Brad Pitt is eating in like 90 percent of his scenes? Apparently this helps him remain casual, cool, and effortless while filming his movies. Food is his prop. Posing empty-handed can feel awkward and stiff, so I like to take photos while actually doing something or using my surroundings. Props add life and authenticity to your images.

Experiment

Take a *lot* of photos, and you're sure to find one that works. However, these are just my personal favorite styles, so don't be afraid to give some other style of posing a shot. Highlight that outfit, show off those shoes, and do whatever you need to do to feel comfortable. It's most important that you feel like you. Let your vibe and authenticity come through in how you want to pose.

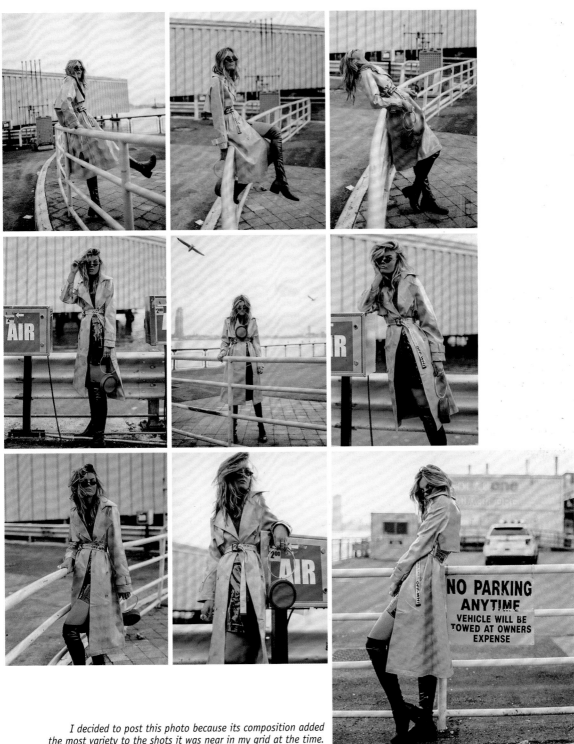

I decided to post this photo because its composition added the most variety to the shots it was near in my grid at the time. I posted all my other favorite shots to my blog.

Selfies

Some days everything is going your way. The sun is out, your hair is looking good, and you just had the best ice cream on planet Earth. You're feeling so good it might just be selfie time. There's nothing wrong with getting a good selfie when the moment is right. With that said, there's nothing worse than trying every angle and scenario but it just isn't coming together. Here are a few ways to make your selfies successful and post-worthy.

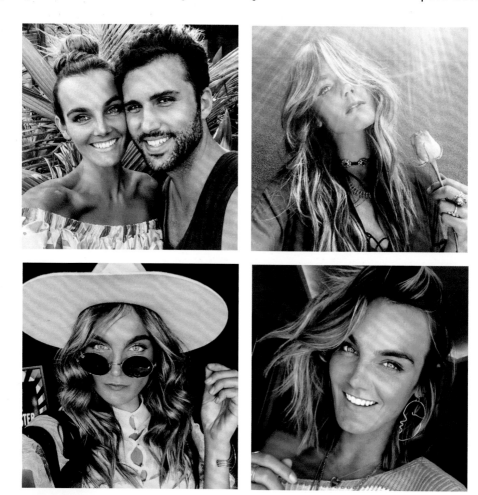

Lighting

As with many other types of photos, lighting is crucial, but it's especially crucial when getting a selfie. Perfect lighting can take your selfie from sad to Selena, and natural light is always the best light for getting a good one. Try to really stick to taking a selfie with soft natural light...that means in a space that is fully sunlit, but the light is diffused. If you take it in direct light, it will look too harsh. Try outside or next to a window. Let that soft, sunny glow light your face like Beyoncé at Coachella 2018.

Smile

Generally, I've noticed that smiling in a selfie really connects with people. It feels good to see a happy face, and it can even change someone's day for the better. You may not be comfortable smiling all the time, and some days may actually call for your best *Blue Steel,* but in general, turn that frown upside down, and show your pearly whites.

Take a lot

One day, when the aliens invade, they're going to steal our phones to learn about us and be in utter shock when they see the number of selfies we take. Don't worry about what the aliens will see or think; use this wonderful, limitless-selfie-taking-power to your advantage. Take 10, or 20, or 30 selfies—whatever it takes to get that perfect one. Change your smile, face angle, and background. Since you don't have to worry about another photographer and it's just you holding the camera, fire away until you get it just right.

Be mindful of your background

While your face may be glowing and ready for a prime selfie, your bedroom may have 12 empty LaCroix cans and a bag of Twizzlers lying around. Be mindful of your background and make sure your space is clear and not distracting. The subject should be you, and you don't want people to notice your messy background.

Commit

Most of the time when I am taking a selfie in public, I am cringing as I feel so embarrassed, and I don't want anyone watching. However, there are those times when the occasion arrises, and I have to push forward and commit. The biggest thing to remember in the selfie world is to just ignore what other people think. If you want that shot, you get that shot.

All about that edit

To me, there is nothing more fun than sitting down at my desk, turning on some tunes, lighting a candle or two, and digging into some fresh pictures to edit. It's your chance to fully express your creative vision. Colors, crops, exposure, contrast, fade, grain, the list goes on and on; there is so much you can do to take your photo to the next level and stamp it with your own creative trademark. I have a few key settings I always tweak when editing. Thank goodness there are so many powerful editing apps out there.

Presets

Occasionally I edit a photo with presets on my phone, but 99 percent of the time I use Adobe Lightroom, and I absolutely love their preset system. It's a quick and easy way to completely overhaul a photo. There are massive preset markets to dig into, and a lot of Instagrammers are releasing their own specialty presets for purchase. So if you have a favorite Instagrammer out there whose photos you absolutely love, take a quick look to see if they are selling their own Lightroom presets.

A preset is a great way to get started, but it's not a one-stop shop. I always begin my editing process by slapping on one of my favorite presets, and I tweak away from there. As you learn more and further develop your own editing flow, you can save whatever editing actions you have done to a photo as a preset to be reused later on. It's efficient, convenient, and allows you to remain consistent.

Exposure

This represents how long your scene was exposed to light before capturing the photo and essentially determines its brightness. If you don't like the brightness level of your photo, start tweaking that exposure slider. I am always changing the exposure depending on the preset I'm starting out with and the way the photo was shot. Chances are that your photo is not lit 100 percent perfectly, but don't fear. Photo too dark? Bring up your exposure. Too light? Bring it on down.

Contrast

Contrast is the range of difference between separate tones, essentially determining how sharply colors stand out from one another. I usually don't tweak contrast a ton, but I do like to slightly push it up or down depending on the photo. Fair warning: don't over contrast! I've noticed when people are just starting their photo-editing career, they tend to overdo it on the contrast, making the photo look fake. Make sure to adjust contrast conservatively with little tweaks here and there.

Temperature

It does just what you think—it makes your photo look warmer or cooler. Examples of when I would want to make a photo cooler is if there are any yellow, orange, or red tones reflecting in the photo. These colors can be reflecting off of surfaces like a building or clothes and can really make your photo a little too toasty. No worries, just cool off that temperature. The same goes for when it feels too blue or white and you want it to look slightly warmer and more welcoming—bring your temperature up a few notches.

Shadows

These are the darkest spots of your photo. These areas consist of no color and can cover up detail. Tweaking shadows is one of the simplest ways to drastically improve the look of a photo. I have taken many photos that have looked too shadowy and almost unusable before editing. I adjust shadows a little and turn that dark mess into a pleasant photo. More often than not I will bring my shadows up, which lightens them and helps reveal the detail they were covering.

Saturation

This determines how intense and bright the colors are in your photo. This is another tool I'm very careful with when using. It's easy to under- or oversaturate, but a little tweaking goes a long way when making sure your photo is appropriately pop-y or muted. If I have a photo involving bright clothes or flowers, I usually up the saturation a touch to really bring those vibrant tones out. On the other hand, if I want my photo to appear dimmer and moodier, I'll slightly bump down the saturation to achieve peak moodiness.

Grain

Adding grain does exactly that—it adds a little noise or grit to your photo. I love adding a little grain to my photos. It gives them that vintage, old-film feel that I can't get enough of. I always use at least a little grain, and depending on the mood or how vintage I want to make a photo feel, I'll even add some more.

Cropping

Cropping impacts how much of your photo you want to show or cut off. I crop to eliminate sky in a photo if I've captured too much, or to focus in on a section of the photo that I think is most important. Cropping is another really fun tool with which to experiment. Sometimes I'll do a really crazy or irregular crop that will completely change the feel of my photo—usually for the better (but sometimes for the worse!).

Tools for a good edit

For me, photo aesthetic has always been number one. I am constantly working on my editing skills, enhancing my Lightroom expertise, working on new presets, and exploring the latest and greatest editing apps. It can feel overwhelming with the amount of editing tools and software available, so it's crucial to narrow it down and find what works for you. Here are the five main tools I use to achieve my feed aesthetic.

1. Camera

I shoot on a **Canon 5D Mark IV.** There are so many amazing cameras out there these days, and they're all great for different reasons. I love Canon because that was what I learned on. Plus, they are very popular, so there are plenty of tutorials and guides to help you learn. If you're in the market for a great camera and the Mark IV is out of budget, I recommend checking out the **Canon 6D,** as it is also has a high-quality camera and can achieve a similar outcome to the Mark IV. There is always your phone as well, and I discuss the pros and cons of this approach on pages 36 and 37.

2. Lenses

The lens you shoot with can really make a photo come to life. There are so many different options when it comes to selecting the right lens for the right situation, but my top two lens choices are a **35mm f/1.4** and a **16-35mm f/2.8**. The 35mm is great for fashion photos. It allows me to get somewhat wide angles while maintaining a soft background and sharp focus, which is an aesthetic I love. The 16-35mm is amazing for epic, adventure photos. The lens gets super wide and makes everything feel so grand. I recommend that you start with one lens, learn as much as you can and master it, then you can move on to another one.

TEZZA PRESETS

In 2017, I released the Adobe Lightroom presets I created and use on all of my Instagram photos, and it has been so much fun seeing other people bring their feeds to life using my presets in their own way. Look at the before and after examples below of how I use my presets. If you are interested in checking them out, go to **www.shoptezza.com,** or explore the hashtag **#tezzapresets** on Instagram where you can see other people using the presets on the daily.

Before *After*

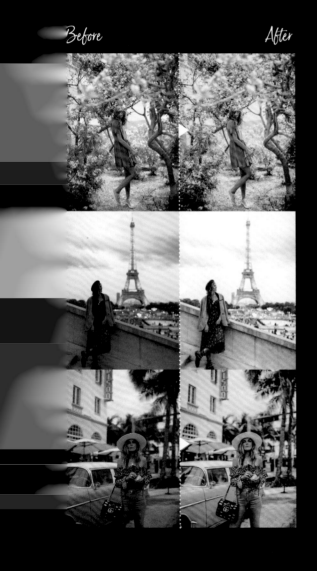

3. Software

If photo editing is something you want to take seriously, I recommend investing in and learning **Adobe Lightroom** for your desktop. It's hands down one of the most user-friendly photo-editing programs out there and gives you so much control over your images. So many 'grammers are releasing their own Lightroom presets as well, so check out what your favorite accounts are using on their photos, and you might be able to purchase them.

4. Raw or JPG?

These are specific image file formats your camera can capture, and it can seem scary, like some advanced thing you know nothing about that makes you want to run the other way. But let me give it to you straight: shooting in **Raw** is and always will be way better than shooting in **JPG.** It's as simple as changing one setting on your camera. The only downside of Raw is that it takes up more space on your hard drive. However, when it comes to editing, you will be blown away by how much control this gives you over your images.

5. Presets

This is my favorite part of editing. Applying your own preset, or one that you have found and tweaked to your liking, is really where the editing magic begins. For you beginners out there, you should know that when it comes to applying presets, it is never as simple as one click and done. All presets have to be adjusted to the photo. Even when I use my own, I find myself constantly adjusting it depending on the lighting, clothes I'm wearing, colors I want to showcase, etc. But sticking with one, or a small number of presets, really allows you to keep a cohesive, consistent feed, even when you are adjusting the filter with additional editing functions.

The editing process

A good edit is the secret sauce to creating a beautiful photo. It takes time, practice, and a whole lot of tweaking to get right, but it's a great way to put your artistic stamp on your work. Lucky for us, we have amazing software at our fingertips that gives us full creative control of our photos, especially using my tool of choice, Adobe Lightroom. I've spent years practicing and perfecting my editing process, so believe me, I know getting started can seem daunting. However, in such a photo-sharing-centric world, we're lucky that experts are putting out guides, videos, and tricks for creating Instagram magic. While there are countless settings and tools to use, this is my basic editing flow to get you started. I essentially use these few steps every time I start editing a photo. So upload your photos, fire up Lightroom, and get started!

presets

temperature

exposure

1. Open your photos in Lightroom and select the one you want to edit. Look to the left to access your presets, and select the preset you want to apply to your photo. In this case, I am using Tezza01.

2. Toggle the temperature and exposure in the Basic panel until it looks good. Usually a simple adjustment of those on a photo can make the preset start to look right. (Your camera settings are always going to be different, so presets won't look the same from photo to photo.)

3. Play around with the saturation and luminance of each color in the Color panel. These adjustments can be tricky, but it really helps bring to life the true colors of the photo.

4. And you're done! Right click on your photo, export it to your desired location, send it to your phone, and GET POSTING. There are so many different tools and tweaks you can use in Lightroom, but this is the simplest form of my go-to, every day edit.

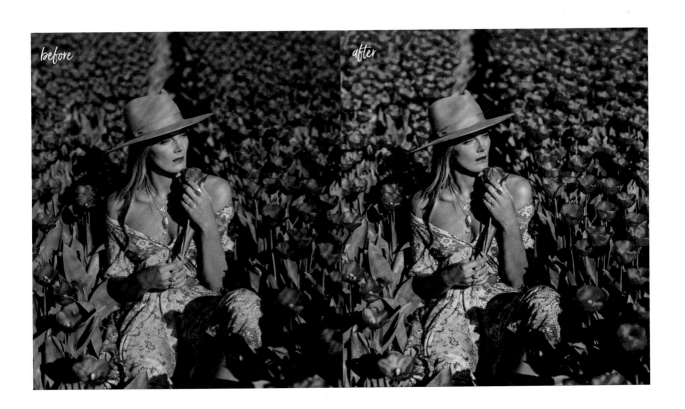

Creating for your story

You probably want some advice from the experts in your niche so you can create stunning, category-specific content that will kill it in your corner of the Instagram universe. The following spreads are some contributions from my friends (and a little more from me), where they generously unpack their wisdom to help you elevate your content and brand.

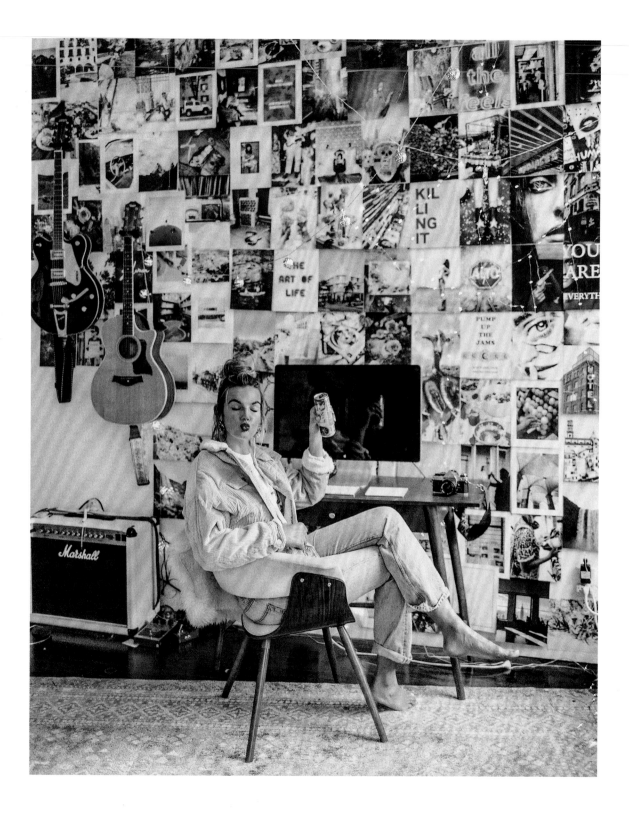

Lifestyle

Don't limit yourself. When choosing your Instagram niche, don't let it make you feel trapped in a box. You are allowed to color outside the lines, and even make up your own category.

MY AESTHETIC

I want my photos to crack, pop, sizzle, and snap. I use my presets to achieve a warm, vintage, moody feed that still has a punch of color and saturation.

My category is the very hazily defined space of *lifestyle*. I want this guide to help you break it down so you see the possibilities. It's a broad category indeed, and I love that it lets me share everything from travel to fashion to cooking to places to eat. It's a natural fit for me, as I have loved filling my life with beauty from the get-go. I'm a photographer, artist, and musician, and I love interior design, travel, and delicious food. I love to find beauty in all life offers.

Contributor: *Yours truly, Tessa Barton*
Handle: *@tezzamb*
Essential app: *VSCO*

Her thing: *I want to give you glasses that show you the world in a new way. While I am serious about the brands I work with and the photos I take, I try to give everyone a good laugh in my captions and hopefully encourage them not to take life too seriously. I want my followers to also live the "art of life," to look for ways to see beauty in the mundane— taking something ordinary and tweaking it just a few notches to make it a work of art.*

What's your favorite quote?
*This one really has shaped the way I view my work: "You will never influence the world by being just like it." Remember this when finding your niche; being different is **good!***

What's the first step toward making my life Instagram-able, like yours? *Style up your humble home. I feel lucky to live in a little box in NYC, and I've learned that even a little box can be magical. There is so much you can do to make it come to life, and there are times that I just never want to leave. It's my place of inspiration. Start with your bedroom, make it a reflection of you, and get photographing!*

Live the art of life

CHANGE PERSPECTIVE. In a rut? Don't overthink it. A lifestyle 'grammer looks for beauty in the simple. Rearranging your room? Show us your cozy bungalow. Cooking in the kitchen? Give us an inside peek. Lifestyle photography isn't about getting precisely perfect shots. It's about images that make you feel; in-between moments are your best friends.

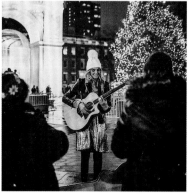

HONE IN ON YOUR PASSION. You surely want to excite and inspire others with your passion. Focus in on whatever it is. I love music—playing it and listening to it—and I really try to incorporate it into my posts. I love to create and share videos of songs I'm writing. I even assembled a public Spotify playlist to share the music I'm currently loving.

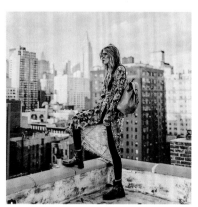

STAY INSPIRED. When building an aesthetic to share with the world, it's crucial to stay inspired. I'm always hunting through fashion magazines, saving photos, watching musicians perform, and keeping my eyes open to the beauty around me. NYC is so full of life. I try to soak in that energy and let it trickle into my creative direction.

TAKE A BREAK. When your life is your art and your work, it can get exhausting. Sometimes it's important to unplug and recharge. Read a book, relax by the pool, or take a nap. I don't do this enough, as I am in love with what I do, but when I'm able to, I find myself coming back recharged, refreshed, and invigorated with a new creative energy.

FEELINGS
ND OVERTHIN KING
BOUT
IT.

Want this shot?

FASHION AN OUTFIT THAT JUST COULDN'T BE MORE YOU, and find a location that matches. You want to be a lifestyle brand because you know your life is unique and worth sharing, so break some rules and do you. I love to Photoshop graphic overlays on my photos because it really rounds out the aesthetic that inspires me.

Grid-spiration

Nine content ideas to share yo' life

1 At home	**2** Exotic sightseeing	**3** With your friends
4 Favorite food	**5** With your significant other	**6** Necessities shopping
7 Family photo	**8** Outfit shot	**9** A passion

Insta-do

+ Stay in touch with popular culture. It helps to be hip. Your cultural literacy can help you connect.

+ Talk to your followers like close friends. Life is real, so keep your speech real. A lifestyle account takes off when it's relatable with a touch of aspirational.

+ Discuss surprising topics. Don't be afraid to talk about issues you care about. I recommend a diplomatic, humble approach, but it's okay to engage with causes.

Insta-don't

+ Don't lose sight of the goal. Let your experiences shape your life, and don't get caught up in doing things for the sake of the 'gram. They're not authentic when they become a chore.

+ Don't focus too much on yourself with posts that have no context. I'm not saying a random selfie is bad, but try to remember that your grid is about sharing experiences. Your photos should have a meaningful footprint relating to your mission.

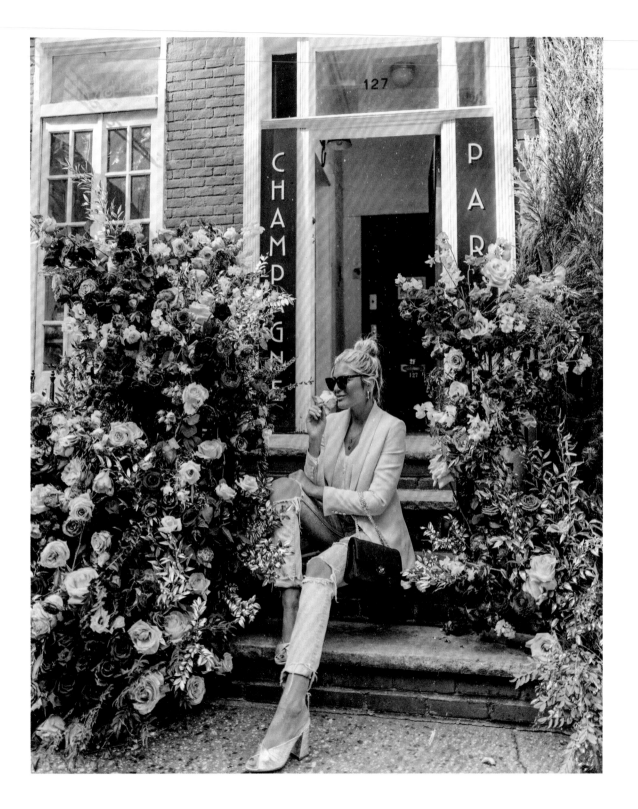

Fashion

When you put pink and flowers together, it makes Emily Luciano. Hone your taste, be picky, and launch that personal style brand that's beautifully and unquestionably you.

MY AESTHETIC

Pinks, browns, whites, and blues. I love to make my photos look bright with pastel tones to create a whimsical look. I wear mostly neutrals, so it's easy to make every photo match in my feed.

If you're like me, the fashion industry is a passion and creative outlet. I'm a Canadian-born style blogger, transplanted to NYC, where I'm incredibly lucky to be living my dream. The mission: inspire and prove to others that fashion can be for everyone. You also can be a founder of your personal brand—develop a consistent theme on your Instagram, learn how to showcase your styles, and you too can create a career that capitalizes on your incredible taste.

Contributor: *Emily Luciano*
Handle: *@emily_luciano*
Essential app: *UNUM*

Her thing: *Emily is a NYC-based style influencer. With the chic-est taste and the perfect photo edits, her grid is unwavering. Followers know they can always expect perfectly simple, yet trendy fashion inspiration. She also shares a sprinkle of lifestyle content, with topics including hair and beauty, artwork, travel, and home design.*

Number one style principle?
I always stick with neutral tones so pieces are easy to pair, creating a very chic look. If you love to wear patterns and color, make sure the colors are in the same tones so your look isn't super loud.

What are your favorite fashion elements? *I love wearing denim— either black or light blue! I find wearing blazers with loose-fit denim bottoms is such a sophisticated look. The denim on denim look is cool right now.*

How do you plan your grid?
First, I curate my closet so that everything is on-theme and easily paired. Second, I use UNUM to lay out my grid and ensure it flows. No matter your style and aesthetic, be aware of what colors are next to each other in your feed by planning ahead with an app.

How to...
Style a photo-worthy outfit

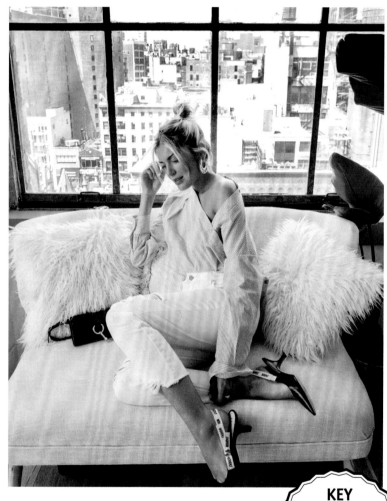

1. **FIND YOUR FAVORITE BOTTOMS**—ones that make you feel amazing. I always start here.
2. **PICK OUT A BLAZER, BLOUSE, OR FUN TOP** that complements the bottoms.
3. **SELECT A NEUTRAL PAIR OF SHOES** that make the overall look cohesive.
4. **THE PURSE AND EARRINGS ALWAYS COME LAST.** Usually a neutral or black purse works best. Adding earrings to any look makes the outfit look complete—I opt for either gold or a pop of color!

KEY APPS

VSCO
Lightroom
UNUM

Want this shot?

+ Focus on the outfit rather than the whole scene. Find awesome locations that complement your look but don't steal the show. You want your environment to look natural and casual—if it's too staged, it's not believable or relatable to your audience.
+ Show some creativity by adding a prop for your look. Flowers are my go-to addition. However, too many props detract from the outfit.
+ Make sure the lighting is right. If your photo is poorly lit or blurry, it absolutely doesn't belong on your beautiful feed.

Insta-do

+ Use your Stories
to create both organic, in-the-moment content, and more strategic, fully produced content. I use apps such as Unfold and 8mm to curate my videos so they stick to my overall brand aesthetic with high-quality posts.

+ Tag locations.
I find using locations that are frequently searched works really well to build my audience.

+ Stick with a theme
and a few colors so that your feed always matches.

Grid-spiration
Perspectives to keep it breathable

1 Same look: full body

2 Same look: waist up

3 Same look: new location

4 With another human

5 Close up

6 Far away

7 Flat lay

8 Photo collage

9 In situ

Outfit-don't

+ Don't wear super oversized sunnies.
This can contrast your chic look in a bad way!

+ Don't wear big chunky wedges
if you're wearing a casual outfit, such as jeans and a tee.

+ See-through tops
can be trendy, but don't use them for daytime looks.

Travel

Travel is learning how to live by design, not default. You can't be on autopilot when going from one country to another, so travel photos need to evoke that feeling of endless possibility and being in charge of your life.

MY AESTHETIC

Nature is beautiful, colorful, and there is very little black and white out in the wild. What really works is embracing the wide range of colors in my feed and sharing photos as they are—jungle greens, desert oranges, sunset pinks, and ocean blues.

Adventurer. Nature addict. Obsessive learner. Storyteller. I am a Polish-born, Australian-educated, Los Angeles-based explorer, writer, blogger, and photographer. Do these words describe you, too? If you are endlessly inspired by connection to other cultures and people across the globe, and if you feel compelled to share your experiences with others, then turn this passion into a career and post your adventures on Instagram.

Contributor: *Aggie Lal*
Handle: *@travel_inhershoes*
Essential app: *Planoly*

Her thing: *Aggie is a travel and lifestyle influencer from LA, known for her bubbly personality and humanitarian work. She encourages her "tribe" to get out of their comfort zones, not only through stunning photos, but also with inspirational, self-growth-themed captions. You'll find Aggie both in 5-star resorts, as well as sailing across the Pacific or remote Amazon jungle.*

Who's behind all your stunning photos and videos? *I can take credit for costumes, art directing, and sometimes post-production, but the person behind the camera is my partner Michael Moretti, a director and photographer himself.*

How has traveling influenced your life? *Everything good about me I owe to traveling. I am more mature, relaxed, open-minded, and kinder because I get to experience the beauty of this world.*

How do you plan your grid?
To me, it's more important to tell a story rather than color-coordinating and laboring over layout. While I know a photo of me in a bikini at the beach will always go well, I try to post a variety of photos from a given country, even if it means having a less perfect feed.

How to...

Travel like a pro Instagrammer

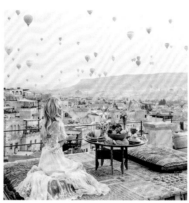

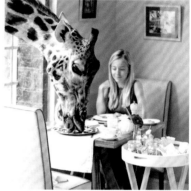

THERE'S NO SHORTCUT. You have to have a huge repertoire of posts and put a ton of work into your content. This is how you convince others that you're worth their time and build a relationship with them. Post consistently every single day, and space it out if you have multiple weeks without traveling to keep it flowing.

HOTEL SMART. Sometimes I'll reach out to a hotel and request a free stay in exchange for posting photos. Other times, I have hotels reaching out to me, offering a trip in exchange for posting. Another trick is to stay somewhere basic and cheap for most of the trip, then spring for luxury accommodations at the end. At the luxury places, stay there AS LONG as you can, and enjoy absolutely everything they have to offer!

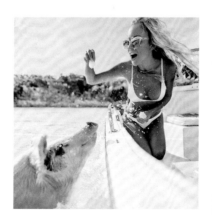

SPONSORED POSTS. Because I respect the attention, time, and money of my audience, I would rather spend my own money to show my followers a place I genuinely think they should visit versus getting paid to show them somewhere or something that might not be of value to them. If it's not a "hell yes" to a destination or product, then it's a "no." I also return products I thought looked good on a company's website but wasn't happy to use and wouldn't recommend to a friend. I think it's important to contrive a variety of income sources so you only need to recommend products you're passionate about. I know it's easy to judge other influencers who do a lot of sponsored work, but don't forget it's the only way to survive and keep doing what others follow us for!

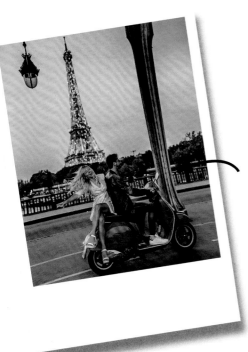

Want this shot?

I USE A CANON EOS-1D X MARK II FOR 99 PERCENT OF MY PHOTOS. It's a professional camera, so it may be a little too expensive for a beginner, but it's great if you want to shoot high-quality videos, as it records slow motion in full frame.

Grid-spiration

Elements of a travel story

1 Natural beauty	**2** On the town	**3** Aerial
4 Iconic sites	**5** Animals!	**6** Epic sunset
7 Up in the air	**8** Food	**9** Underwater

Insta-do

+ Find a balance between bucket list locations you are dying to visit, such as Machu Pichu, Santorini, or Bali, and places off the beaten path. The travel space is overflowing with Bali swings and Santorini breakfast spreads (mine included), so in order to stand out, try hitting some less obvious destinations such as Portugal or Poland!

+ Take a friend. It's always more fun to travel with company, and it's also more fun to see pictures of friends having fun together. Support, shout out, and share the love for other influencers as much as you can!

Insta-don't

+ It's not too late to start. You don't have to be the first person to do it, you just have to do it better, and you are better by being yourself. I know your taste is killer, but I also know that your creative content won't be at first (no one's is). You have to keep working at it consistently to close the gap between your taste and your content.

+ Don't check other creators first. That's how I stay original. I prefer not to search what other people have done at locations before I get there.

Food

People eat with their eyes, and nowhere more so than on Instagram. Your Instagram food photos need to pop off your feed and leave your audience wanting more.

MY **AESTHETIC**

Light and bright with pops of color are the main components of my feed. I love the feeling of a crisp, clean feed with strong images that jump off the page. I stick mainly to greens, browns, pinks, and purples, but add in a few different colors occasionally.

Food photography should encapsulate a moment of pure deliciousness that your audience just *has* to be a part of. From healthful weeknight dinners to decadent desserts, people love to share their favorite meals with the world. Combining the right lighting composition, styling, and editing will have your audience wanting to reach into your photo and take a bite!

Contributor: *Erin Jensen*
Handle: *@thewoodenskillet*
Essential app: *Lightroom*

Her thing: *Erin is the photographer, recipe developer, and content creator behind The Wooden Skillet. She loves sharing inspiring, healthful meals, real food, healthy living, and so much more. You will find lots of dairy-free, paleo, and vegan recipes, but also the occasional indulgence and cocktail—because you gotta have balance!*

What's in your camera bag?
(1) Canon EOS Rebel SL1 (2) Canon 50mm lens (3) white backgrounds (4) reflector (5) diffuser (6) tripod (7) artificial light (8) lens cleaner

Where do you find your inspiration? *Everywhere! Instagram, restaurants, magazines, Pinterest, cookbooks...I take it all in and keep a running list of recipes I want to develop and shoot.*

How to...

Style a food photo

1 LIGHTING. Pick your main subject (in this instance a stack of pancakes), and find some natural light. I typically shoot between 11 A.M. and 3 P.M. using light from the north, if possible. The best days to shoot are cloudy ones. If you have to shoot on a sunny day, place a diffuser between your window and your subject.

2 BACKGROUND AND PROPS. Your background is the foundation of the photo and shouldn't take away from your subject, but rather provide a neutral, complementary base. I suggest white, grey, or light blue. Your props should also be fairly simple, as they too shouldn't detract from your main subject. Use your props to help tell the story of your shot. My favorite ones include linens, utensils, and small prep bowls filled with the ingredients used in my recipe.

OPT FOR ODDS

Odd numbers are more appealing to the eyes. I generally buy three of all my props.

MUST-HAVE PROPS

1. One set of tall glasses
2. One set of short juice glasses
3. Neutral linens
4. Cheeseboard
5. Pouring vessel
6. Vintage utensils
7. Greenery
8. Basic round plates (salad- and appetizer-sized)
9. Small, neutral prep bowls

3 KEEP CHANGING IT UP. Taking 50 photos of the same exact setup isn't helpful. Once I take a handful of shots, I always add more or move a prop. In this pancake example, some people may stop styling here, but if you look at the next step, I decided to try to stack even more blackberries and bananas on top with a sprinkle of pecans. It looks infinitely better. Then in step 5, I add some simple flowers for a touch of green and femininity. If I had stopped here at step 3, I wouldn't have ended up where I did. Keep changing it up and paying attention to those little details.

4 MOVEMENT. This is one of the most important, yet most difficult tips to grasp at first. You should use your subject and props to help the viewer's eyes move through your photo. In this picture, the eyes starts on the tie of the pitcher of coffee, then move over to the top blackberry, down the stack of pancakes, and finally to the dish of butter. The fork is strategically placed to point at the pancake stack. All of this movement helps direct the viewer's focus to my subject. This effect creates a photo that's easy-on-the-eyes, and therefore more likable to your audience.

5 ANGLES. I always think through all of my options and plan out my various shots before I set up a shoot. I consider what shots I can take straight-on (like with this stack of pancakes), which ones I can take from a 45-degree angle, and those that are best taken from above. For Instagram, straight-on shots and overhead shots are generally more popular.

6 MONEY SHOT. When I'm styling a shoot, I take various snaps from all angles, making changes as I go. Then, when I know I have all the still photos I want, I almost always get an action shot. This may be a scoop of food or a pour of a drink or sauce. There is something about these shots with distinct movement that people gravitate toward. They take practice, and you ruin your perfectly composed food in the process, but it is so worth it when you get that perfect money shot!

Insta-do

+ Edit. Taking a perfectly-composed photo is only half the work. The other half is taking the time to edit your photo to really make those colors pop. I edit in Lightroom as an essential part of my food photography.

+ Pick a color story. To develop a recognizable brand on Instagram with a feed that stands out, you really need to stick to a set of complementary colors. Look at a color wheel for inspiration!

+ Keep it minimal. When you're looking at someone's feed, the pictures are small. Refrain from getting too busy with your styling so the subject always pops.

+ Be seasonal. People want inspiration for what is current. Don't take a sweet picture of some grilled chicken in the middle of winter. I promise it won't go over well with your audience.

+ Tag big accounts. A great way to gain exposure is by tagging those accounts which feature other Instagrammers. Some of the big ones are @thefeedfeed, @foodandwine, @bestofvegan, and @real_simple.

+ Pick a niche. If your account is all over the place, it'll be hard to target and grow a specific audience or a specific community through your feed.

+ Use Stories. Your audience wants to know the person behind the camera. Cook recipes, show behind the scenes, and offer photography tips.

Beauty

You don't have to be the most beautiful or the most knowledgable. Everyone's definition of beauty is unique. As long as you're creating content that makes your heart aflutter, it will resonate with your audience.

MY AESTHETIC

My feed is rainbow-tastic because it revolves around what hair color I'm currently doting on. I keep my hair and makeup the star of the show by increasing saturation, and I always use a muted, clean background.

My Insta-journey didn't begin with beauty. I started with a fashion-based Instagram account, posting OOTD-related content. It wasn't until I noticed that my hair and makeup posts would always get the most love and attention that I listened to the calling, and I have focused on beauty ever since. If you don't know what your niche is yet, stay attentive to your audience. They might have the answer for you!

Contributor: *Alanna Durkovich*
Handle: *@xandervintage*
Essential app: *VSCO*

Her thing: *Alanna is a beauty influencer from Vancouver, Canada. She started with a focus in fashion, but her colorful aesthetic and original makeup portraits have turned her into a beauty maven. She keeps things fresh by experimenting with endless hair colors and beauty trends. Xander Vintage is all about being playful with makeup, trying something new you haven't tried before, and feeling good in the skin you're in.*

Where did you learn how to apply makeup and style hair?
I love going on YouTube and learning new skills and tricks (i.e., how to create a waterfall braid or how to apply cut crease eyeshadow). I'm not a makeup artist, so I take any chance to educate myself on beauty trends so I can produce streamlined content for my own Insta-account.

Do I need special equipment to become a beauty influencer?
If you have a backdrop and decent camera, you're on your way, but if you want to elevate your photos, invest in lighting. Good lighting is everything. Don't want to break the bank? Start off small and purchase a ring light. It produces a soft, flattering light that will improve your portrait shots immediately.

How to...

Become an Insta-beauty maven

FOCUS ON HAIR. Everybody has hair, but not everybody knows what to do with it. Share your hair knowledge! From simple to more complex, it will always be appreciated. Plus, everyone loves a good braid post.

MAKE A VIDEO. Showing your audience how to create a look with video is a powerful tool. It's an opportunity to let your personality shine. Don't be afraid to get silly. Film like no one's watching!

GO OUTSIDE. Most beauty posts are created in a room with closed doors. Change it up and venture into the great outdoors. Shooting outside can freshen up a monotonous beauty feed...and nothing beats that moment when the sun hits just right.

RECREATE. Creative block? Pay tribute to your favorite beauty Instagrammer and recreate a look of theirs with your own twist. It's creating content, giving a compliment, and engaging with the beauty community. Just don't forget to give credit where credit is due!

Want this shot?

SOFT, DRAMATIC LIGHTING!
Golden hour is the moment before sunset when the sky is flushed with warmth. This soft light creates photographic magic, and using it for your beauty look is a must. This image was created indoors during golden hour, manipulating light and shadow from the blinds on my office window.

Grid-spiration

Nine beauty posts for a fresh feed

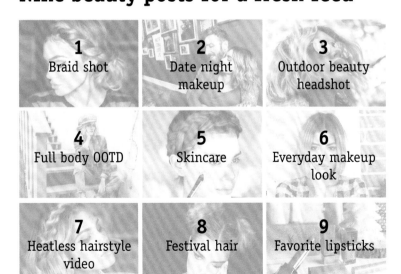

1 Braid shot

2 Date night makeup

3 Outdoor beauty headshot

4 Full body OOTD

5 Skincare

6 Everyday makeup look

7 Heatless hairstyle video

8 Festival hair

9 Favorite lipsticks

Insta-do

+ Use Highlights.
This helpful tool groups your beauty Stories by category (i.e., FAQs, unboxings, makeup swatching, or current favorite products). It's also a great way to attach any affiliate links you may use when sharing cosmetic websites.

+ Be real.
It's easy to fall into sharing only the flawless, airbrushed image of perfection when it comes to beauty posts, but everyone has imperfections. Don't be afraid to share them with your audience. A little vulnerability is important when shaping authentic relationships with followers.

Insta-don't

+ Don't ignore your followers.
You want them to feel connected to you, and responding to their comments is a good start. Fostering those relationships should be a daily practice because then they will keep coming back with more love.

+ Limit hashtags.
Don't get too hashtag-happy. Try to use between 5 and 10 hashtags that actually relate to your post. Too many can look messy and amateur.

+ Avoid uninspired song choices.
Take time to find the music that best suits your video because the right song can tug at the right emotions. Plus, if your followers like the song, they'll probably watch the video for longer.

Family

Being a mom has always been my biggest dream in life, and Instagram is such a fun way to document that journey for me. My husband and I love to sit in bed and look at old Instagram posts or blog posts of fun times we spent together as a family.

MY AESTHETIC

I love a lot of color, and my closet is filled with mostly brights and fun prints. That makes my feed pretty colorful! I edit my photos in Lightroom and use whichever filter I like best for the mood of that picture. I love to use filters from other bloggers or photographers who sell theirs online.

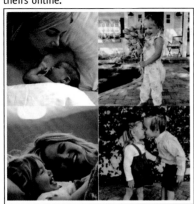

My Instagram feed is really a representation of every stage of my life. As my family and I evolve, so does the content I share. I don't use any apps to plan my feed, and I try to show what I am up to at any given time. I love to share my style, hair and beauty inspiration, and fitness tips, along with all my favorite family photos. Sharing all these moments of real life is something your audience will also connect with, helping your followers to feel inspired as parents.

Contributor: *Amber Fillerup Clark*
Handle: *@amberfillerup*
Essential app: *VSCO*

Take candid photos with your kids

Her thing: *Amber is an all-around lifestyle blogger living in the desert with her husband, two kids, and dog. She blogs about anything involving living your best lifestyle: beauty must-haves, hair tutorials, all things travel, posts from everyday life, and tips on topics such as productivity, happiness, parenting, and more. Amber believes life should always be fun, that we need to be present in each day we live, and that we should work hard and play harder.*

What's your number one goal?
My number one goal in life is to be a good mom and be there for my kids. Everything else comes second.

What's the most difficult aspect of your career? *As a working mom, it is so hard to find a balance between working and parenting. When I am focusing on just my kids, I feel guilty for not being there as much for our employees. When I am being a great boss, I feel guilty for not being with my kids. It is a constant struggle, but I hope one day my kids realize that all this hard work was for them, and that they see they can achieve any dream they have.*

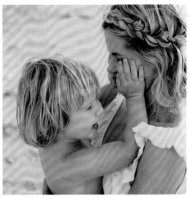

THE PHOTOGRAPHER. I'm lucky my husband takes my photos, so he is able to easily pull out the camera when he sees a candid moment he wants to capture. However, if you're going to a photoshoot and want to capture similar candid photos, make sure you find a photographer around whom you feel comfortable, and set up a large time slot. Since your kids will feed off your energy, you don't want to be rushed, and you want to be as relaxed as possible.

THE SHOOT. Instead of asking the kids to smile or telling them you are doing a photoshoot, plan a fun experience where you know they will be smiling and happy. You could be doing an activity, such as feeding ducks, and ask the photographer to stand back and capture moments as they happen. If you want a more posed family photo, hold them or have them right next to you, and tell a really funny story. By the end of the story, they're laughing, and that's when you look up at the camera and the photographer can snap away!

SET REALISTIC EXPECTATIONS.
Don't seek perfection in family photos and shots of you with your kids. Often the best photos are the real moments and emotions captured in shoots, so try not to set the bar too high. Look for the beauty in each shot, even if it wasn't what you had pictured in your head.

Want this shot?

FAMILY PHOTO TIME! Since my husband is the photographer, sometimes it's hard to get the whole family in the shot, which is when the self timer comes in handy. We either use a tripod, or if we're outside we'll set the camera on a nearby rock or surface. Most DSLR cameras have modes where you can set it to take up to 50 frames in a row. We will click, run into place, and have a little tickle fight or tell funny jokes to keep the mood nice and happy.

Grid-spiration
Variety for your family-focused feed

1 Mom's day off	**2** Matching outfits	**3** Posed family portrait
4 Kiddo beauty shot	**5** Play date	**6** Selfie shot
7 Healthy fam	**8** Little victories	**9** Sweet moments

Insta-do

+ Be confident.
Being a mom on social media means everyone is sharing their opinion on your parenting. Be confident in your approach and realize there are so many ways to parent correctly. Not everyone will always agree with you, and that's okay. As long as your kids are happy and thriving, you're good.

+ Be real.
I try my best to share the not-so-great moments along with all the great ones. It's hard to find a balance with this because I want my kids to look at my blog and see how much I enjoyed and lived for being their mom and not read me complaining, but I also want to let other women know that it isn't always picture perfect. Being a mom is hard, and I think we can all bond over that.

Insta-don't

+ Stop comparing!
Look at your feed...I'm guessing it's mostly highlights. Well, same with the other mom bloggers. Try to be inspired by another mom's parenting style, and maybe carry some of it into your own style, but don't get down on yourself. We're all doing better than we think.

+ Don't feel like the fun is over.
You can still travel and work once you have kids! My 3-year-old has seen 25 countries. I definitely believe all the travel with the kids plays a huge role in their patient personalities. As for working, you may just have to bring them along or work different hours; I'm often at the office from 7 P.M. to 1 A.M. when the kids are asleep.

Health and fitness

"Success is never owned; it's rented, and rent is due every day." When I'm feeling less than motivated, I remind myself if I'm not consistently perfecting my craft, I'm going to be left behind. Challenge yourself, take ownership of your influence, and do great things.

MY AESTHETIC

I like my photos to evoke all the nostalgic and happy feels with creamy beige and vintage blue tones.

As a wife and a busy mom to two little girls, I saw the need to offer women a solution to staying fit and healthy. For six years, I've been sharing my journey to stay fit during every season of life. From workout videos and recipes, to lifestyle photos and fitness routines with my babies, I have been able to share a realistic approach to health and fitness. If you have a passion for health and helping others, Instagram is the perfect place to share your mission.

Contributor: *Alexa Jean Brown*
Handle: *@alexajeanfitness*
Essential app: *Lightroom*

Her thing: *Alexa is often referred to as the "Fit Mom" in the fitness category, offering her audience a wide variety of fitness and health tips for the busy, on-the-go woman. Life gets busier and busier all the time, and Alexa's goal is to provide a no-excuses, realistic fitness and health routine where anyone can achieve their best self.*

What's the key to staying motivated? *Find your "why." Identifying your sole reason for doing what you're doing is going to keep you focused when you want to quit. I get in ruts sometimes (frequently, actually), but my "why" always keeps me coming back and reminds me why I started. My personal "why" is to show busy women (and moms) that feeling great about yourself is possible; you can have it all!*

What critical piece of advice can you offer for aspiring influencers? *Be different. Define what makes you unique and how you can offer it up to the world. People don't want another cookie cutter social page, so get creative and do something different.*

Gain a dedicated fitness following

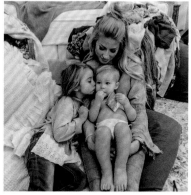

IDENTIFY YOUR WORKOUT NICHE, AND CREATE GREAT CONTENT. Define what you're most passionate about sharing and who your goal audience is. This allows you to effectively cultivate a powerful and dedicated community. My corner of the internet is at-home fitness for the busy woman. This is where being different comes in. Offer your audience content that is creative, effective, and realistic. My focus is to show busy women that they can fit in a workout with unique body-weight exercises that can be done anywhere. My video posts and fitness guides offer followers all the knowledge they need.

BE TRANSPARENT. People genuinely just want to connect and feel like they belong; sometimes showing those not-so-pretty parts of life is the best way to show people that life isn't always rainbows and butterflies. I had a friend tell me that he admires how genuinely transparent I am while still maintaining privacy. Transparency doesn't mean you have to reveal every single detail about your life. It might, but it doesn't have to! I try my hardest to put my true, unfiltered self out there. It can spread more love and hope than you can imagine (but I will admit that I *love* a beautifully styled photo).

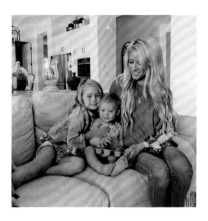

SHARE A VARIETY OF TOPICS. It's important to model a realistic healthy lifestyle for your audience. Sharing content that is lifestyle and health related will broaden your reach and engage your audience. I love to share photos of my daily life to remain connected with my audience, as well as topics that are at the top of the mind for health-centered women.

Want this video?

ALL YOU NEED IS A TRIPOD, (I use a Manfrotto), iPhone, and a video-editing app such as iMovie. Design your workout, setup your tripod, and record! Then trim your videos together, speed them up or slow them down, and add music. Keep in mind the attention span of your viewers is limited; showing a brief 4 to 5 reps per exercise is ideal.

Grid-spiration

Variety for your fitness feed

1 At-home workout video

2 Food fuel

3 Partner workout

4 Equipment shot

5 Motivation video

6 Personal product promo

7 Lifestyle post

8 Transformation

9 At-the-gym

Insta-do

+ Be consistent.
Don't go too long without posting. Set a goal for the number of times you plan to post per week, and stick to it. Going dark for too long can negatively impact your engagement. A posting schedule is a lifesaver!

+ Give them what they want.
While I may not care to know what Fiona Fitness is eating right this second, your followers may! People are genuinely curious about a zillion random things. Learn what your audience craves, and give it to them!

Insta-don't

+ Avoid responding to negative criticism.
There is always someone out there who has nothing nice to say, but the best way to diffuse negative comments is by ignoring them. Getting into an Insta-battle is never a good idea.

+ Stop overthinking it.
It's easy to start worrying about what your peers will think of you when you're yet another person who decides to start a social business. But your voice is unique, and you have an opportunity to change the world. Plus, let's be real—this gig is super fun! So tell that inner mean girl to sit down. Share the photo, share your heart, and rock this social media thing.

Interior design

I believe through inspiration, people choose to raise their own bar. I try to evoke a sense of peace, highlight the organic, and create a love for design details. It's not just about the beautiful finishes; it translates to the way we really live.

MY AESTHETIC

Warmth, comfort, and light. Real fibers, solid bronze and brass, raw concrete, limestone, lathe, plaster walls, natural succulents, rock crystal. My energy is derived from traditional roots with modern expression, merging clean lines with historical foundations.

I believe we are innately driven to surround ourselves with beauty. Instagram is where I establish the voice of my design ethos. It's where I radiate my aesthetic and freely share tips, trends, and truths. I can't say enough about how vital integrity is in home finishes, but even on the 'gram itself, it's critical to be authentically you. As deeply personal as it can be, you have to live the life you show. I post in order to elevate, inspire, and teach. My hope is that through the platform, those who may not have the chance to hire an interior designer will find their way to a more beautiful home.

Contributor: *Anne-Marie Barton*
Handle: *@annemariebarton*

Her thing: *Her favorite style is the one she's currently working on, and her 'gram tells the story. From a 40's-style historical remodel to a modern mountain retreat, she lives for the challenge and the quietly enjoyed personal success. Anne-Marie inspires others to live a life that's both beautiful and practical. Decorative lighting is her thing. Rugs are her thing. Sanctuary living is her thing. Relying on texture, not color, is her thing.*

What's your background?

I moved eight times before high school, and my parents built a new home in every location. I grew up with samples floating around at all times. I watched my mom telling builders this and that, with no training but a ton of courage. I found myself drawn naturally to the hands-on education provided by my parents. This career of designing homes was inbred, and therefore it came quite naturally.

First project? *When I was twelve, I desperately wanted to design my bedroom. I learned then that sales is a big part of designing. My dad offered to pay half, and I sought the rest by selling Avon door to door. Four months later, my 70's wicker swing chair was hung with safari bedding to match.*

How to...

Create a grid that radiates integrity

FOCUS ON A STORY. Space out your grid with flow in mind. Move from detailed shots, to shots with you in the photo, to grander shots that show everything. I like to post at least five photos per project to engage and immerse followers.

STAGE SHOTS THAT ARE RICH IN DETAIL. Photos that show the quality elements of your design are wonderful for catching the eyes of your audience. These shots are also perfect teaching opportunities to unload your wisdom about the small things.

PLACE YOURSELF (OR OTHERS) IN THE PHOTO. This brings your design to life and personalizes your feed. Be candid, engage in action, or look busy and natural while in the middle of a busy installation. It's all about the texture and the experience, brought to life by being real.

FULL-SCALE POSTS ARE ALSO NECESSARY. They offer needed perspective. When you're so engaged in architectural details, seeing the exterior elevation lends credibility.

REMAIN TRUE TO COLOR WITH YOUR EDITING. Not only are followers on Instagram looking at the photos, but also publications. Showing the true colors you have created in your design is critical. Even if you use many different photographers, always make sure your post-production edits are consistent. I opt for a drier palette overall, which keeps everything more natural.

INVEST IN QUALITY. Above all, your photos must remain an extension of your brand. Hire a professional photographer! Put forth the effort to stage and ensure the house is ready to roll. Invest the time and money to be sure your feed represents who you truly are.

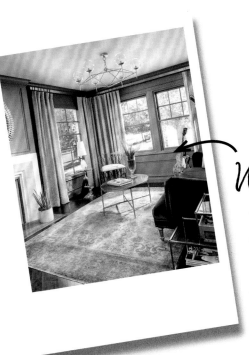

Want this shot?

+ Turn the lighting off and work with natural light.
+ Stage realistically. Throw in a pair of leather shoes or some rhubarb on the cutting board. Fresh flowers are too obvious.
+ Retouch out things such as switches and outlets. Make sure bedding and towels are neat, desktops tidy, and dishware on display. Simplify, stack, and reduce clutter.

Insta-do

+ Design with details that matter.
Be willing to get into the weeds to perfect the shot.

+ Keep the mood and colors seasonal.
Go a little darker and dramatic during winter and brighter and airier during spring.

+ Make a mark in your captions.
Your voice gives others the confidence to try your ideas.

Grid-spiration

Teach and inspire with the whole story

1 Front door details	2 Favorite detailed feature	3 Props that tell a story
4 Short teaching video	5 Staging your design	6 Unexpected perspective
7 The full room	8 Bird's eye	9 Exterior elevation

Insta-don't

+ Never post a careless shot
that may detract from your curated brand.

+ Don't overdo it.
Not everything needs to do the talking. Thin out; allow a clear focal point.

+ Avoid window glare
by shooting with the windows behind you.

+ Don't rely too much on color
in your grid. Texture creates more drama and impact.

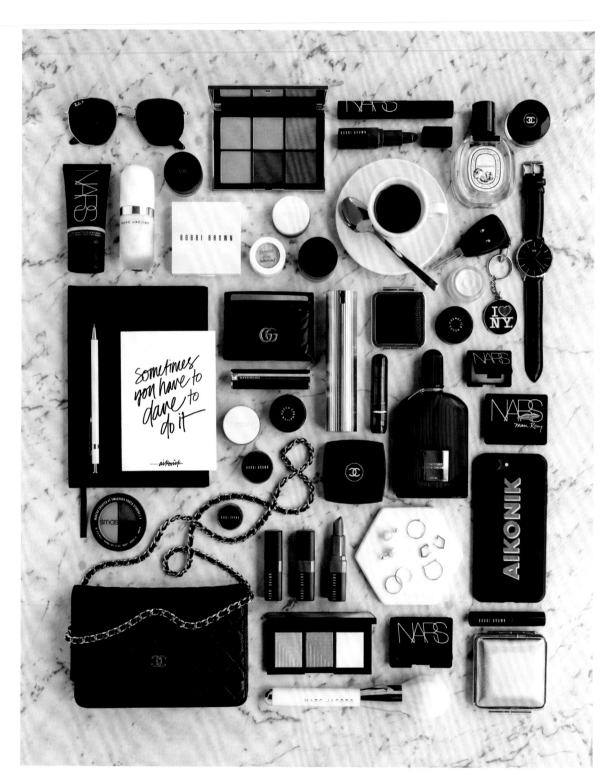

Flat lays and products

A perfect flat lay will always have a selection of precisely positioned, color-coordinated, engaging items that will instantly grab your attention.

MY AESTHETIC

Monochrome, color-coordinated, and detailed-but-concise are the essentials. My feed at a glance is very complex, but each image works individually with its own color scheme, theme, and composition. What I find enticing is the application of bright whites, crispness, and clarity.

Flat lays are the ultimate way to curate and showcase your essential and favorite items, all in an eye-catching image. Well known for perfectly arranged, strategic placement, and shot from a bird's-eye view, flat lays are the perfect way to engage the attention of your audience and brands you love. From a lust-worthy beauty haul, a faultlessly folded OOTD, or workspace essentials, flat lays are a fundamental part of any lifestyle feed.

Contributor: *Carissa Smart*
Handle: *@designbyaikonik*
Essential app: *Lightroom*

Her thing: *Carissa has always been drawn to the style of flat laying, as she has an eye for detail and precision. Producing a flat lay a day, on average, for the past four years (that's over 1,500 photos) has enabled her to expand her visual imagery. It's also helped her to develop a continuously evolving personal style, displaying her workspace, outfits, and beauty products in captivating ways.*

Why did you choose flat lays as your niche? *I have found that my followers are continuously drawn to beautifully composed and structured imagery, which gives them an insight into "my world," aimed to inspire both visually and technically. Whilst my flat lays showcase my lifestyle, they also appeal to those interested in the featured brands, and in turn gain attention from the brands themselves in a creative way.*

Who's behind the ideas and photography of your flat lays? *From start to finish, I have total control of art direction, product placement, photography, and post-production. My background as a communication designer and photographer has certainly enhanced my eye for design.*

How to...

Construct a flat lay

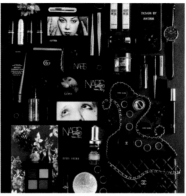

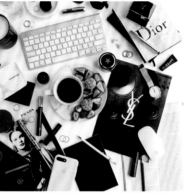

1. THEME OR HERO PIECE. Every flat lay begins with choosing a theme or hero piece. Whether you select specifically by color, or start with one item (or many) and surround it with complementary items, the options are endless. If you do focus on theme, select items that relate to each other to draw attention around the frame, creating a scene or story.

2. COLOR. One of the key elements to engage followers is with color. You can base your flat lay on a monochromatic color scheme or highlight an item by surrounding it with black and white items. An audience is more likely to engage with an image when a color theme is involved or when the palate is especially aesthetically pleasing.

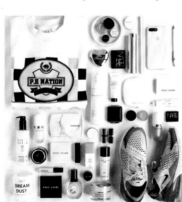

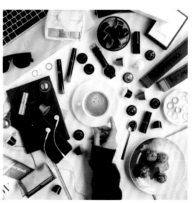

3. COMPOSITION. Aim for organized chaos, simplistic and minimal, or lots of detail. Fill the entire space, or leave negative space; there are no rules! Work from biggest (or hero piece) to smallest to determine the number of items needed to fill space. Create interest by layering. Move your hero piece around; it doesn't have to be in the center.

4. NATURAL LIGHT. Plan the shot near a window or outside, but not in direct sunlight. To minimize harsh shadows, use a diffuser or piece of white board to bounce light back onto the items. Using a DSLR gives you the freedom to adjust aperture and shutter speed to achieve the right light. Shoot mid-morning for soft light, and avoid afternoons.

Want this shot?

It's called a shelfie: combination of part selfie and part shelf. Shelfies are an essential part of any Instagram grid, usually a perfectly curated, sophisticated image of a beauty or makeup collection. This is certainly a skill to master, but once you do, your followers will all be rearranging their beauty cabinets!

Grid-spiration

Six creative ideas to change up your flat lays

1
#OOTD

2
Breakfast spread

3
Workspace

4
Makeup essentials

5
Suitcase packing

6
On the bed

Insta-do

+ Different backgrounds

+ Change up the angle

+ Get close up

+ Hands in frame

+ Bird's-eye view

+ Play with lighting

Elevate

Optimize every post to captivate your
audience and elevate your brand

Your first posts

Welcome to the Instagram world! You are now ready to toss up your first few posts. No pressure at all—you've got this. Remember your story, stick to being authentic, and go for it. The hardest part is starting, but once you do, the rest will flow nicely.

Introduce yourself

Use your first post to introduce yourself. Give people a little insight into who you are, what you're about, and why they should be excited about following you. It can definitely be longer than your bio, but don't get too long and drawn out. Keep it exciting and injected with your personality.

Once you have done your first introduction, and your following has grown over several months, feel free to reintroduce yourself to your new followers. Who knows how people stumbled upon your account in that time frame; they may not know much about you. Give them a peek into what drives you, show off your personality, and reinvigorate your following.

Build your feed first

You don't want to let loose on Instagram too soon. Don't go following a bunch of accounts and commenting all over the place until your feed is visually representative of your mission. Get a few posts under your belt, get your grid looking nice and feeling legit, then let yourself start engaging with the community and growing your following. I would recommend getting at least nine photos posted so your feed looks full and enticing to people looking for someone new to follow.

STARTING ON DAY 1

You're ready to go, and your amazing creative content is saved in a folder on your desktop. But actually you have only three followers (including your best friend and her boyfriend).

+ Post nine photos. Do it now!

+ Then post at least one photo, consistently, every day, from now until...well, I don't actually know why you would want to slow the momentum.

+ Work really hard to get your first 200 followers, and give them LOTS of Insta-love with likes, comments, and DMs.

+ Create relationships with existing influencers, and ask if they'd be willing to work together.

+ Implement hashtags and location tags as if your life depends upon it.

+ Give each post time and effort.

+ Listen to your audience. Remember, this is a community.

Now go get 'em, tiger!

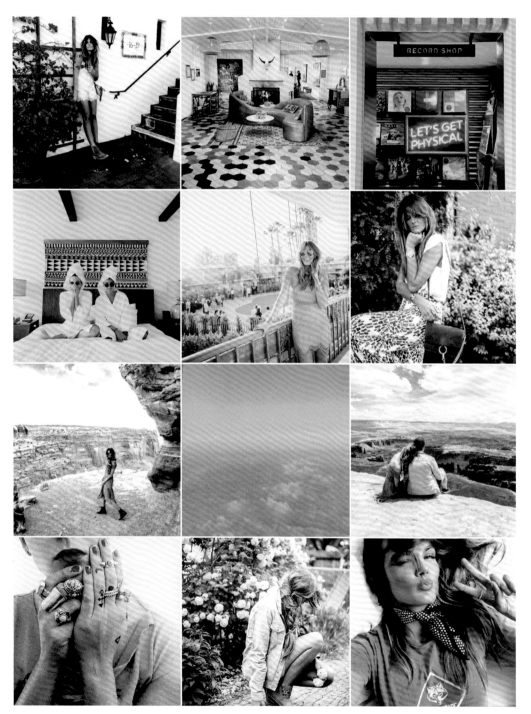

Obviously my aesthetic has evolved since 2013 when I first started using Instagram, but it was around this time that my content began to tell a consistent and more focused visual story—this is when I began to seek ways to boost my creative content and think through the business potential of Instagram.

Your caption, your voice

You have been searching for inspiration, scouting locations, gathering props, and shooting for hours. You've edited your photo to perfection and are ready to post it. Phew, the work is all done. Not so fast! You are forgetting one of the most important, and perhaps the hardest, parts of posting on Instagram—the caption. It's where you can really let your voice shine through.

Keep it real

There's no right way to write your captions. Find what works for you, and roll with it. I love inspiring others not to take life too seriously and to try something new, and I love trying to make those around me laugh, so this is the tone I carry in my Instagram captions. Other people are beautiful writers, and they share long, inspiring stories and ideas. I follow artists whose captions are simply the names of the artwork they are posting. I also have friends that post the first thing that comes to their mind or a literal description of what's going on in the photo. And guess what? All of these approaches work. What matters most is that they come from an authentic place and are consistent with the story you want to tell the world.

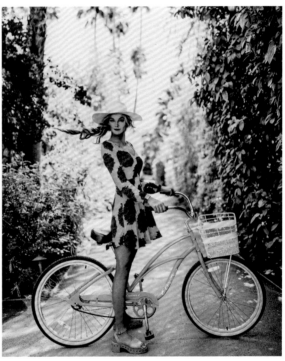

tezzamb I came, I saw, I forgot what I was doing. 🌸🌷🌺🍃 @misterzimi

Your captions are your chance to let your voice shine through, providing the perfect complement to your photos.

Practice makes perfect

Honing your aesthetic is vital, but don't forget to hone your voice as well. It's what can separate you from the pack and keep people coming back for more. Writing is *hard,* and it takes just as much practice as creating beautiful visual content. Here are some of my recommendations for improving your caption-creating skills.

+ **Tell a true story.** People really connect with personal stories, and every Instagram post is a chance to tell one. Your caption could be a reminiscent story inspired by your Instagram post or a behind-the-scenes peek at how the photo was captured.

+ **Say it out loud.** When brainstorming caption ideas, I like to say aloud random things that are on my mind or related to the photo. It helps me find the right words. Sometimes I'll stumble upon a rhyme or a pun this way that I can incorporate into the caption.

+ **Come up with several options.** I often write several caption ideas before settling on one. Sometimes I like certain aspects of different caption ideas, which inspires me to combine them to create a whole new caption that ends up being the one I post.

+ **Have a point of view.** You come from a unique background and have your own story to tell. Let this point of view shine through in your captions. People appreciate a new and unique perspective, and you are the only you out there who can provide yours. Instagram is a great place to start a discussion or movement, so if you have something you're passionate about, get the conversation going in your captions and see how people respond. You may find like-minded individuals with whom you can have an interesting dialogue, or you may learn from the diverse perspectives of others.

Insta-do

+ **Reveal the goods.** If there is a main point you want to make, or something you're asking for, put it in the beginning of the caption.

+ **Involve your followers.** Engage directly with your followers. See page 157 for ways to use captions as an engagement tool.

+ **Carefully choose hashtags.** These can really elevate your platform. See pages 162 and 163 for an in-depth discussion.

Insta-don't

+ **Don't misspell things.** Use your dictionary, and ask a friend to proofread it. Incorrect spelling, misused words (unless intentional), and poor grammar happen to the best of us, but they look sloppy and signal carelessness to your audience.

+ **Avoid long hyperlinks.** Since users can't click on links in captions, and since Instagram doesn't even allow users to copy the caption text in their feeds, a long hyperlink is useless...put it in your bio, instead.

WANT TO USE LINE BREAKS IN YOUR CAPTION?

Instagram doesn't allow this directly in the app, but you can type hard returns into any text editor, then paste it into the caption field in the app.

Stories

Instagram Stories are as beneficial to your brand as chocolate chips are to a cookie—they may not be totally necessary, but they definitely make your Instagram a much better experience. These photo or video posts appear separate from your grid and will disappear within 24 hours. There are a million ways to go about your Stories, from being extremely raw and personal, to being over-the-top professional and commercial...it just totally depends on your niche and authentic personality. Here are a few ways to achieve success when deciding what direction to take your Instagram Stories.

It's fun to pose questions and get real-time responses from followers

STORIES IN ACTION

Stories have lots of features and formats that will continue to evolve with the platform. Click around so you can share your post in the most unique way. The app allows cool things like: Boomerang videos; Rewind (videos in reverse); clickable handles, hashtags, and location tags; superimposed text and drawings; face filters; tags for the current weather or time; and so much more! All these things really elevate the story you want to tell to something relatable and interactive.

Connect with followers in unique ways, share messages you care about in a more intimate way, and get the word out when launching something new.

1. Talk to your followers

There is nothing that draws in a follower more than making them feel as if they're part of your day-to-day life. From taking them with you throughout a busy day, to showing them your creative process, to explaining your new recipes and why you came up with them, all of these peeks into your life help your followers learn about who you really are.

2. Swipe ups

Swipe ups have been a game changer on Instagram. This feature allows you to add a link to a Story, so that with a simple swipe up on the phone screen, your followers will be directed to the linked webpage. If you have a new product launching, you can take your followers right to your site; if you have a new song you want to share, they can immediately listen with a swipe up to Spotify; if your latest workout routine is on the blog, they can immediately follow along.

3. Make it pretty

Use one of the many amazing editing apps on your phone to quickly make your Story photos beautiful before posting. Toss on your favorite VSCO filter or AfterLight effect to give your Stories their own unique feel.

4. Take a poll

Getting feedback from your followers and letting them know you care about their opinions is an amazing way to connect, and also a great way to gather information that will be helpful to you. Instagram launched a poll button allowing your followers to vote on something you propose. If you are working toward launching a product and want to know what your followers think, ask away. Or maybe you simply want to know if they are as obsessed with ice cream as you are—ask 'em! Whatever the question, that information is so vital in helping you grow your business and brand, while ensuring followers know they're valued.

I used Stories to take everyone with me through New York Fashion Week 2018. Here are just a few!

Gave the whole narrative a beginning with this Story

Used the Boomerang feature for a fun snippet of me swinging this bag

When you find a vintage bike and bouquet that match your outfit, do the right thing, and

Stories are a good place for silly, less curated photos

Story Highlights

Highlights are a feature that allow your Stories to live on forever on your Instagram page, rather than disappearing after 24 hours. They can serve as a highlight reel of your favorite Stories and experiences, or they can be a permanent spot to display Q&A sessions so you don't have to answer the same ones over and over again.

When to make a Highlight

A simple method to determine what makes a worthy Instagram Highlight collection is to ask yourself this question: What do you write or talk about most through your Instagram account? If you notice themes within your writing or posts that you want to keep returning to—then boom! You have a topic worthy of a Highlight, and now your followers have a place to click and always access that information.

Highlights perpetuate the value of your amazing Stories.

A Highlight reel promoting my collage kit

A clickable link to move over to my product account

Easily link to the product webpage with a swipe-up feature

Good Highlight categories

Here are some of my favorite ways to use the Highlights feature, but don't limit yourself just to these! Get creative and use Highlights to further tell your story.

+ **Locations** If you are a travel blogger or someone who showcases your favorite spots around your city, create travel guides and post them as Instagram Story Highlights. New York, Italy, Hawaii, Spain—wherever you go, make a separate Highlight for each location. Your followers will love to come back and reference them as they're planning their own travels.

+ **Campaigns** If and when you start booking campaigns with brands to feature their products, a Highlight is a great way to expand on the product and get more personal with it, showing how it actually works for you.

+ **Tutorials or tips** If you love to educate your audience on topics that you're an expert on, you can have your own little YouTube channel right on your Instagram page. Whether it's your favorite make-up tips, hairdos, cooking tips, or fitness guidance, a Highlight is a perfect place to create a guide that people can revisit.

+ **Launches and announcements** Instagram Highlights are also a great way to announce a new launch of some kind. This can be the launch of a new blog layout, a new YouTube video, or a new book. Let your followers know when you're up to something cool to get them hyped on it as much as you are.

Some of my highlight collections

Europe #TURNUPT... COACHELLA PRESETS NYFW PFW CHLOE COLLAGE KIT 2017

Here are some of the Highlights I have on my profile. The Highlight icons sit between my bio and my grid. New followers can click through them to get an idea about my personality and content, and old followers can relive their favorites.

Videos

Sometimes a photo just won't suffice, and you need to share your creative vision with movement and sound. There are so many video possibilities, and it's a completely different beast compared to the photo. You'll want to make sure you're carrying out that same feel and aesthetic you've crafted so well for your photography, bringing it into your video work.

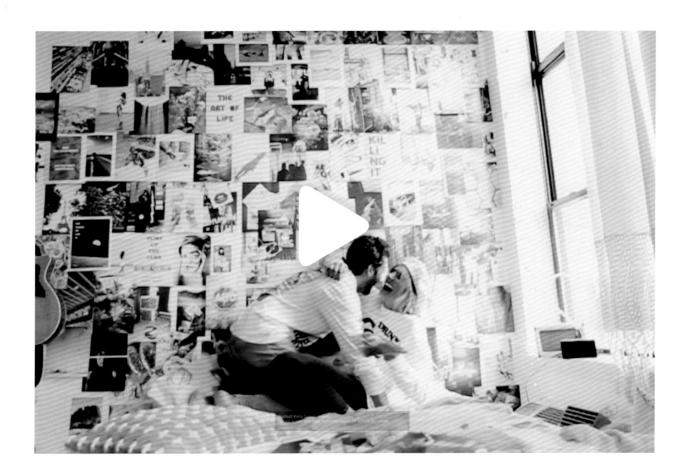

Do it your way

Don't think you're locked into doing video a certain way; make it feel like you. Make use of videos as an even more immersive and engaging way to share your vision and spread your story. For example, I love taking photos that have energy and excitement, that feel like a moment you want to jump into, and I try to carry that over to my videos. I do this by combining clips and doing choppy cuts between them with a fitting tune playing throughout. That's my style; you'll find one that fits your brand, too.

+ **Keep it candid** I have friends who go the more candid route and simply talk to the camera, sharing ideas or starting conversations with their followers. This is a great way to engage and create a more relaxed feel with your audience.

+ **Boomerang** I love using the Boomerang feature in Instagram. If you open up your Stories camera inside the app, Boomerang is among the many fun tools available to you. Hold down the capture button and do your thing for a few seconds. Next thing you know, you'll have a short, continuously looping video that adds a little energy and movement to your feed.

+ **Get vibe-y** People will be browsing their Instagram feeds in situations where they won't want to play sound out loud. We're looking at you, guy on the subway, blasting the volume on his phone so everyone can hear. So with that in mind, try to make videos that can hold their own without any sound. Think beautiful scenic shots, or simple edits with added text on top of the video to provide a little context. A quick selfie vid to show off your look for the day works, too.

Maintain your aesthetic

Just because it is a new medium doesn't mean you need to sacrifice your aesthetic. Some of my favorite photo-editing apps for smartphones offer video-editing tools as well, and there are some apps meant exclusively for video, which I love.

+ **VSCO** I talk about VSCO several times in this book...it's just that good. This app has a feature allowing users to apply the same presets normally reserved just for photos to videos, as well. So focus on your few favorite filters and apply them to your videos to keep your unique vibe and feel throughout *all* types of your posts.

+ **8mm** I *love* this app. The developers recreated some vintage 8mm film effects, and they add such a vibe to any video. I use it all the time and can't get enough.

These are my two favorite methods for maintaining my aesthetic across all of my photos and videos, but there are many other great apps out there to check out. iMovie is good for making quick cuts and overlaying text; Clips is great for combining clips and stills to make a single video in a simple interface, and Filmmaker Pro is perfect for more powerful and advanced tools. Give VSCO and 8mm a try, but explore what else is out there to nail down what works best for you.

Be discoverable

Growing your following can take some serious work, and all that hard work can go to waste if you're not taking measures to make yourself discoverable. Remember when we talked about good ways to explore Instagram with click-spirals (see p27)? Well, others will find you the same way. A key component to growing your following is enabling other Instagram users to stumble upon your feed as they're browsing around.

Location tags

Believe it or not, location tags help growth immensely. From my own experience, I have found a lot of phenomenal accounts by exploring tags of places I'm going to visit as I'm looking for inspiration. Location tagging is especially important when traveling to a hot vacation destination, as a lot of people, including myself, will scout out the tag of a vacation destination to find great photo ops, dining spots, or activities. Who knows, you may take the next iconic New York City Instagram photo that will be discovered over and over again by people perusing the NYC location tag on their way to visit.

Hashtags

Using a strategic and selective combination of hashtags can cause an immense surge in growth. I delve more into hashtagging later, but I must discuss it here briefly, as it is critical for discoverability. Not only can you use generic hashtags that generate a lot of posts, such as #marriage, #cute, #travel, etc., but you should also look at more specific hashtags. This can include anything from specific branded hashtags, event hashtags, and even a unique riff on a generic hashtag.

Tag brands and other big accounts

On every Instagram account, there is a tab where you can see all the posts in which the user is tagged. For example, if I tag @cole_herrm in a photo, it won't show up on his feed, but anyone can see it in the Tagged tab of his profile. Thanks to this section, you have another great way to be discovered. Not only is there data behind this, but I've personally found some awesome accounts while digging through photos in which a brand or big account is tagged. So be sure to tag relevant accounts in your own photos. Someone may be looking through tagged photos of Gucci to get inspired for a new outfit or photoshoot, and BAM—there you are in all your glory with a new Gucci bag, and also a new follower.

Comments galore

Commenting is a simple and obvious method to enhance discoverability. As you comment around the Instagram world, your profile will more widely proliferate, and people will stumble upon you while scrolling through comments of a friend or another big account. Your next witty comment on Kendall Jenner's latest selfie could inspire one of her millions of followers to click on your account and become a new follower.

Geotag your location: it can be broad, like the whole country, or you can make it much more specific

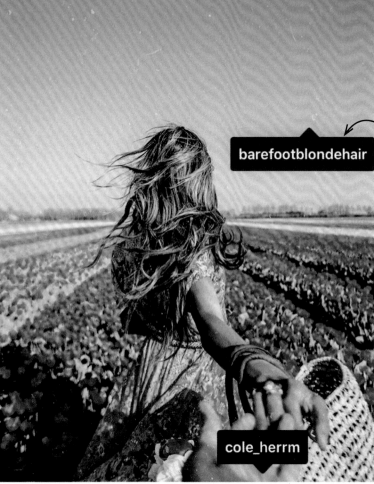

tezzamb
Netherlands

barefootblondehair

cole_herrm

Tag the brand in the photo

Liked by **alexiaaleza**, **newdarlings** and **41,560 others**

tezzamb Some old-fashioned things like fresh air and sunshine are hard to beat. 😊
#BFBHairEverywhere #tezzatravel

Use hashtags relevant to the photo

Engage with your followers

Getting personal with your audience is a great way to expand your following. Your followers want to know you're a real person and will appreciate the effort if you like their photos, give them a follow, respond to a DM, or reply to a comment. This can seem daunting, and it takes a ton of time, but a little effort can go a long way. Directly engaging with your audience in unique and fun ways can turn them into dedicated fans who will grow with you over time. Here are several ways to do this.

Set aside some time

As your following grows, it can feel overwhelming to respond to everything that comes in. It helps to set aside an allotted amount of time per day to focus solely on engagement. It's amazing how much you can get done even in just 30 minutes. Cruise through your comments and respond along the way. Pop into DMs and respond where you need. A little bit of focused time will pay off in the end.

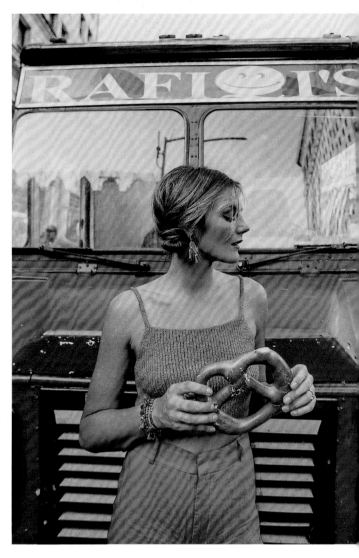

Respond via Stories

If you find your followers reaching out with the same question over and over, it can be helpful to do a bulk response in your Story—sometimes it's just too dang hard to get to every single one individually. There are two really simple ways to do this.

1. Screenshot the photo that is getting similar questions and comments, post it on your Story, and write the answer over the top with Instagram's handy text tools. This is a super simple way to engage with your audience, answer their questions, and save yourself a ton of time.

My original post

My Story response to questions about my shoes

2. Sometimes I make a video Story as well, actually saying the answer aloud. This is not only a great way to answer a common question in bulk, but it also gives you a chance to show off more of your personality and connect with your followers through a different type of media.

Instagram is about giving, as much as taking.

Like other's posts.

Comment on what you love.

Give them a follow.

Respond to DMs.

Reply to comments.

Run a contest

Who doesn't love a chance to win some free stuff? This is another great method to drive engagement. I love hosting contests on my feed...it's a fun way to give back to my followers. If you are hosting the contest on your own, without the collaboration of a brand, then invest in some awesome products to give away. They don't need to be anything fancy; a favorite new beauty product, a trendy accessory, or an Amazon gift card will do.

However, you may not need to do it alone because brands often see the value in contests. Pairing up is a great method to help grow both your following and theirs. If you're considering hosting a contest to give away some free product, reach out to the brand to see if they would like to get involved. They may gift you a free product to give away and even share your feed on their account to increase awareness of the contest. It's a win-win: your account generates excitement and growth around a contest, and the brand generates more visibility of their products.

How to manage a giveaway

Make sure to keep the steps to enter your contest simple and straightforward. I usually ask users to do something such as: (1) Like this post and follow my account, and (2) tag two friends in the comments.

I might remind everyone that their account needs to be public in order to be eligible. I also set a deadline for the close of the contest. It's up to you how you choose a winner...it could be at random, or you could choose an account you think stands out the most. Lastly, announce the winner on your feed or in your Story. Your followers will be hyped! Just don't forget to update the caption once the contest closes.

tezzamb
Versailles, France

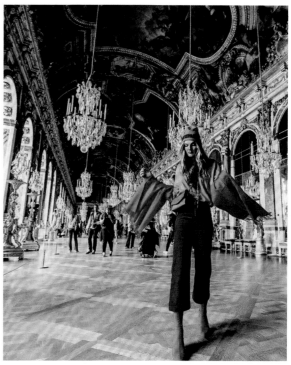

Liked by **zoelaz**, **alexiaaleza** and **35,777 others**

tezzamb ⚡ GIVEAWAY CLOSED!! ⚡ I am super excited to be teaming up with a few of my amazing friends to share our preset packs with you! One winner will win ALL of our preset packs 🎉
All you gotta do is follow us:
@tezzamb
@tyfrench
@aspynovard
@jacimariesmith
and tag your friends in the comments, cause duuuh friends are the best!! Good luck everyone! 🖤
Giveaway closes at 12PM (PST) #tezzapresets

Here's a contest I ran with some friends, giving away our presets. It was a great way for all of us to elevate engagement.

Hold a Q&A

Another fun way to build interest and elevate your influence is to hold a question and answer session. People follow you for a reason: they think you're interesting and inspiring, and they appreciate your creativity, so give them a chance to ask you questions about what you do and how you do it. It may feel funny at first; I know I was nervous about answering people's questions publicly, as I'm still learning so much every day. But everyone has their own unique perspective on Instagram, so don't be afraid to go for it.

Ways to run a Q&A session

You can approach a question and answer session in a couple of different ways, depending on your comfort level.

1. Comments Sometimes when I post on Instagram, in the caption I'll ask my followers to ask me questions in the comments. Later I'll select my favorite or the most frequently asked questions and answer them in the comments feed, in my Story, or on a blog post.

2. Stories Post a Story, asking your followers if they have any questions about X, Y, or Z. Then follow up with another Story to reply. (It could be a static text reply, or a video.)

3. Live Live streaming yourself is an exciting way to answer questions, as well. Just announce beforehand the exact time you plan to go live to answer questions. No pressure or anything, as you're interviewed and broadcast to your followers in real time! It can definitely seem daunting, but the more I've done it, the easier it has become. It's a great way for people to see you in a new light, live and in action, and not just as static posts in their feeds.

MORE ENGAGEMENT STRATEGIES

There are many creative methods for drawing your followers in. Try some of these out, as well, and see if they work for your account.

+ **Ask the audience a relevant question** in the caption of your post, or post a Story poll. It could be anything, such as, "Do you like eating chocolate for breakfast as much as I do?" or "What is your favorite type of group fitness class? Looking for ways to spice it up!"

+ **Request your followers to tag a friend** in the comments section. You can drive a lot of new traffic to your profile this way. Try a caption such as, "Love exploring the mountains with my best friend. Tag your best friend below!"

+ **Post consistently.** Instagram rewards users who use their app regularly. The more you post, the more you'll appear in people's feeds.

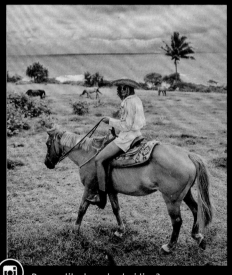

Do you like horseback riding? Yay or Neighhh #tezzatravel

When and how often

Determining *when* to post to Instagram is almost as important as determining *what* to post to Instagram. Even though everyone's feed is algorithmically determined (Instagram predicts what each user most wants to see and puts it toward the top of their feed), the time of day you post still matters. Your followers will generally be more active on certain days and at certain times, so it's important to be paying attention to that data so you know when to post. Throwing your content out there at the right time, and consistently, results in maximum impact and engagement. Find that posting sweet spot!

When to post

If you post a photo on Instagram and no one is around to see it, was it even posted? Don't let your hard work go to waste by posting at the wrong time. We all want to create and share things with as many people as possible, and the best way to determine when you have the greatest reach is by digging into your analytics.

I usually dig deepest into the analytics provided by Instagram and UNUM. The best times and days to post can change slightly week-to-week, so it's crucial to always check and update your posting schedule. I also find it best to check more than one app to see when the suggested best-posting-times overlap. This tends to provide me with the optimal posting schedule, as just relying on one analytics tool can sometimes be hit or miss.

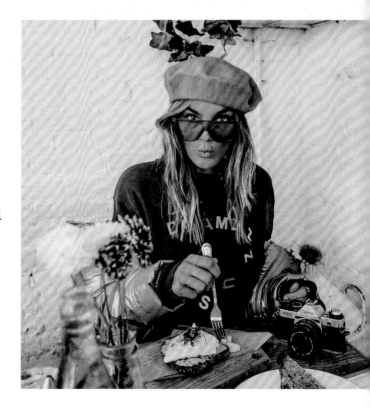

MY WEEKLY SCHEDULE

I have a general schedule for the best times to post (Eastern Time), but I'm always tweaking. Since I'm not the best at following rules, at times I just go for it and post whenever. Sometimes that works too!

MONDAY
I try to post between **noon** and **1 P.M.**, usually with a favorite spot I captured over the weekend.

TUESDAY
Between **11 A.M.** and **noon** is the sweet spot.

WEDNESDAY
Again, between **11 A.M.** and **noon** is best, and is usually a better day for me than Tuesday.

THURSDAY
Between **11 A.M.** and **noon** is the sweet spot here, but early evening is good, too. If I have two post-worthy photos lined up, I like to post twice.

FRIDAY
Earlier in the day, around **11 A.M.**, is prime. I find people are out enjoying the start to their weekend in the evenings, so I steer clear of posting then.

SATURDAY
They tend to be slower since it seems like people are out and about, not necessarily on their phones, but **noon** is when I'll get a post up.

SUNDAY
This is another good day for a double post. I shoot for around **11 A.M.** and **5 P.M.** People seem to be enjoying their lazy Sundays, hanging out and checking their phones often, so it's a high engagement day.

USE ANALYTICS

Stop guessing! Luckily there are loads of free apps and tools to help you determine what time is best to post based on the performance history of your account. These two are my favorite:

INSTAGRAM INSIGHTS
This is a useful tool given to any business account. Navigate to the Followers section, and you will see the day broken out by three-hour periods, each color coded in a different shade. The darker and taller the bar, the more likely your followers will be active then. Post in these time frames, and you have a greater chance of reaching peak engagement.

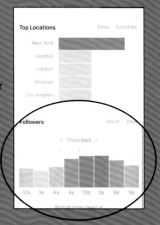

UNUM
Remember UNUM, the handy grid-planning app? Not only is it great for planning, but it also has useful analytics for determining the optimal times to post on Instagram. Navigate to the Best Times section, which breaks down your week by the hour with circles differing in sizes. The bigger the circle, the more likely your followers will comment and like if you post at that time.

How often to post

I always aim to post at least once per day at a peak time gleaned from my analytics. This works well for me, and it seems to be the norm amongst my fellow 'grammers. However, if I'm on a super cool trip, or participating in something like New York Fashion Week or Coachella, I may post up to three times in a day. I'm cranking out more content during those times, and I don't want to be posting event-specific content days after the event. I also like to take people with me when I'm in a unique destination, and I find that posting multiple times makes it fun and engaging for my followers.

Try to get mentioned or reposted

Getting mentioned or reposted by a big brand or account can be a huge boost to your growth. While it's impossible to provide a surefire recipe for achieving this, here are some tips and tricks that have worked for me in the past.

Use their handle and hashtags

This is critical for getting noticed by a brand and will put you in a prime spot for a repost. Make sure you're tagging all of their appropriate Instagram handles, both in the photo itself, as well as in the caption. It's also critical to use their hashtags. Some brands will institute a specific hashtag that they are focused on and really trying to build content around. If that's the case, you need to be aware of what that hashtag is, and use it in your post. I've really noticed an emphasis from brands around their hashtags, so I can't recommend using them enough when aiming to get a repost.

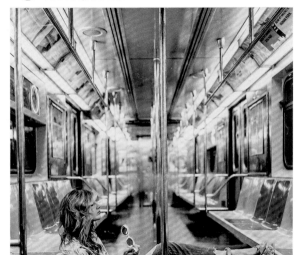

tezzamb
New York, New York

30,025 likes

tezzamb Taking the 6 headed downtown for a fun day with @dsw and my #dswstylesquad 🌸🚇

Brand handle

Brand hashtag

Research their feed and content

Once you've identified whose attention you want, study them. You shouldn't totally morph your style to fit a specific brand, but at the same time you do want to make sure that the photo you want to be reposted is aligned with the brand's feed aesthetic. If it is a brand you love and wear all the time, this hopefully shouldn't be too hard, as you probably already connect with the brand's style and message. Not only should you dig in to what types of photos they post on their own, but also look at the types of photos they repost from other users. Hopefully you can recognize some patterns to emulate.

Choose accounts that actually repost

Before spending time, effort, and money trying to get a brand to repost you, first make sure they actually repost. Some brands are locked down and only post their own content, so make sure the brand you are targeting actually reposts content from the community.

Do something outside the box

While still maintaining a compatible aesthetic and feel with the brand, try to do something totally different with their product. Think of yourself as the new Creative Director for the brand. How would you shoot their Instagram content? Put your own stamp on something, and think of their product in a different way. The effort and unique vision will be appreciated and noticed and can really help in getting a repost.

Don't include competing brands

Trying to get that Nike repost but are wearing an Adidas hoodie? Not gonna happen. Make sure you're conscious of the brands included in your photo, and try to make sure that the brand you want to notice you is the focus. In no way do you want their products conflicting with or being overshadowed by another brand.

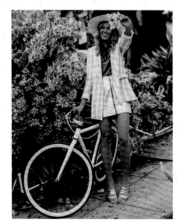

#DSWStyleSquad

Optimize #hashtags

Hashtagging your posts will index them in the Instagram world according to what was hashtagged, allowing users anywhere to stumble upon your account. Anyone with an Instagram account could search #LAtravel or #dinnerideas, and next thing you know, you have a new follower. You don't want to under- or over-hashtag, and you want to make sure you're using the right ones. The most important thing to remember—be intentional with your tags. Something that seems so simple actually takes a little extra work to really grow your following.

Choose the right ones

It is good to use a mix of general and specific hashtags. General hashtags generate a lot of posts, and thus generate a lot of traffic, so they're good for getting some initial attention and extra engagement. However, to gain solid, long-term, dedicated followers, it's wise to use hashtags that are more direct and specific. For example, instead of using #newyork or #foodie, use #newyorkfoodie. It's more tailored, so there will be less competition for your post to get noticed under that hashtag, and it targets a more specific audience that is likely to engage (not just New Yorkers or foodies, but foodies in New York).

Event or branded hashtags are also great for growth and increasing engagement. Whether it's Coachella or Oktoberfest, see if there are any specific event hashtags that you can include in your posts. People not at the event will be checking out the hashtag to see what they're missing, and people at the event will check it out to reminisce or connect with others there.

#tezzanyc

#bytezza

#tezzapresets

#tezzacollagekit

#tezzatravel

Use the correct number

This is something you don't want to overdo or under-do—you need to find that sweet spot. For me, I never use more than eight hashtags. If you use too many, you may appear desperate, dilute your brand, and attract spammers. Remember that your goal is to drive high engagement; therefore, while a lot of hashtags might surge your follower count in the short term, it's likely that your engagement would actually drop over the long term. On the other hand, if you only use one, you aren't using the full potential of discoverability through tags. So always use a couple of strategic ones, but generally never more than eight to ten.

Hashtag your Stories

Not only should you use hashtags in your normal Instagram posts, but you should add them in your Stories, as well. This is something that can easily be neglected, but is another useful avenue for growth. If you click on some of your favorite or higher volume hashtags, you'll notice you can now watch a conglomerate Story made up of other accounts using that hashtag in their Stories. It's another fun and engaging way for others to discover your feed and entice them to tap that Follow button.

Experiment

These tagging techniques have worked well for me, but with that said, everyone's Instagram experience is different. The right combination will involve tweaking and experimentation. It's worth noting that there is much diverse and conflicting advice surrounding hashtags and the correct number to use. Instagram allows as many as 30 hashtags on a post, so explore what works best for you and in your niche. Try different types of hashtags, popular hashtags, fewer, more, etc. After a few tries and some analysis, you'll have a good idea what the perfect hashtag combo is for you.

Insta-do

+ Follow hashtags in your niche. If you're a health 'grammer, follow #cleaneating. Posts with that tag will appear in your feed, and you'll stay up-to-date with trends. This means that your hashtagged posts could show up automatically in another's feed, as well!

+ Hide your hashtags to keep the caption space clear. After posting, immediately add a comment with the hashtags. Once another comment or two has been added, the tags will be hidden behind the "View all" button, so your post doesn't look cluttered.

+ Make up your own. As your brand becomes more refined, you have an opportunity to establish and promote your own hashtags and grow a community around your brand.

+ Save a list of your favorites. You'll probably find yourself coming back to similar tags, so save a list on your phone, constantly refine it, and you can easily paste them into your 'grams.

Insta-don't

+ Avoid irrelevant hashtags. Check out the popular content of a tag before you go adding #fitspo to a photo of you lounging in bed. An annoyed user who sees something off-topic under a certain tag can red flag your post, making it algorithmically less discoverable.

+ Steer away from massive tags. If a hashtag like #love has over a billion posts, it's likely not worth adding it to your post. Find something more specific where you may actually have a chance to be discovered.

+ Don't neglect the analytics! Instagram Insights will tell you how many impressions you made via a post's hashtags, so reflect on those results.

Make some Insta-friends

I am continually shocked and elated at how supportive, positive, and engaging the Instagram community can be. Sure, there are trolls and haters out there, but most of the time I have great interactions with people. Use this massive global network of inspiring and creative people to make some real Insta-friends. Meet up, plan a collab, or go on a trip together. Yes, it might seem a little crazy, but I've made some of my nearest and dearest friends this way and have met some truly incredible people. It's entirely possible to initiate meaningful relationships on Instagram and turn them into real-life friendships.

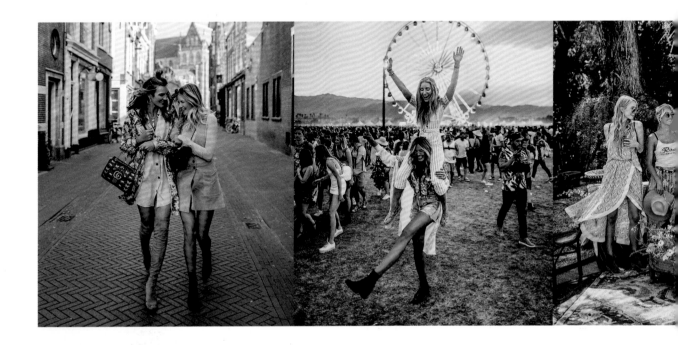

Follow, like, comment

This may sound super obvious, but start following people who you think are like-minded, inspiring, and who just seem downright cool. Like their photos, comment on their stuff, and get a conversation going. It's easy to think someone may never see your comment, or that they are too cool for you because they have too many followers, but everyone is a person, just like you, and they're also likely looking to connect with others. It means a lot to someone when you express support and admiration and participate in their feed.

Shoot them a DM

You're following some cool people, and you're looking to branch out and make some new friends—shoot 'em a DM! Let go of any hesitation or embarrassment you may have reaching out to someone you don't really "know." Like I said, everyone is a person, just like you, and I always find it fun to get DMs from interesting, new people. You never know when it can flourish into a solid, new friendship.

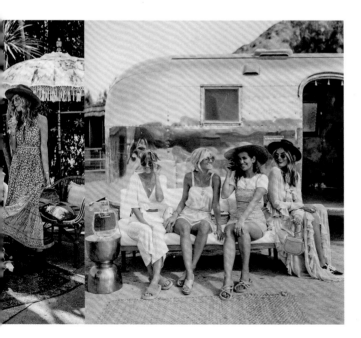

Arrange a meet up

The Instagrammer world is big, but super small at the same time. We all often go to the same events and explore the same cities. Next time you're headed somewhere cool, or if you notice someone you follow on Instagram is coming to your hometown, see if you can arrange a meet up. I have met some people this way who have turned into some great friends from all over the world. Get some shots together, post about it on your Stories, and collaborate with each other. I always find it fun to see who is hanging out and creating magic together, and I'm sure your followers will like it too.

Look up local Instagrammers, too. I'll never forget moving to NYC, having no friends and no idea what I was doing, but I was lucky enough to be invited to a brunch with some other Instagrammers based in NYC. It was life-changing! The relationships I made at that brunch have turned into my strongest friendships in the city. You never know when a casual meet up can turn into a lifelong friendship, so let go of your worries and reach out!

Stay in touch

Share the love with your Insta-friends by staying in touch. We're all in this together, trying to learn and grow as much as we can, and it's fun to have people to vent to, learn from, collaborate with, and hang out with. Not too many people understand how hard, fun, crazy, exciting, and exhausting Instagram can be, so when you meet people who are in it with you, those relationships can be so valuable in helping you through the ups and downs.

Analytics, analytics, analytics

I love digging into my analytics. They're fascinating and educational—these metrics tell me so much. I learn about my audience: what they like and dislike, where they're from, how old they are, and the list goes on. It's really cool to see the types of people with whom I connect while making my Instagram experience much more personal.

Impressions

This is the number of times a post has been viewed, including both followers and non-followers. Your number of impressions is very valuable, as it helps you detect which posts are the most impactful and drive the most traffic to your page. I find that when my impressions are high, more people discover my page and I experience a spike in growth. See if you can observe any patterns in your posts with the most impressions. Learn from it, and go get shooting.

Likes

It's fascinating to see which posts drive more people to double-tap than others. You may spend days creating the most amazing post, but it just falls flat in terms of likes. Who are you even, and what is going on? It can be so confusing and frustrating. Luckily, you can dig in and find out exactly which types of posts drive thumbs to double-tap, and which ones don't. I always pay attention to this and find common themes among the most-liked.

Most saved

Impressions are great to see what makes your feed discoverable, and likes are interesting to see what causes a follower to engage, but most-saved posts take it a step further. Not only did someone like your photo, but they made an extra effort to save it for later reference so they wouldn't forget about it. It must be good! Make sure you take some time to reflect on these analytics and learn from them. What causes someone to *like* a post and *save* a post can be totally different things. Your most-liked content might be something more exciting and vibrant on someone's feed, while your most saved might be more inspirational or informative. Both are valuable, and both are worth taking time to learn from.

INSTAGRAM INSIGHTS

You should use any analytics apps accessible to you, but the metrics directly in Instagram (available to business accounts) are especially useful. You can see which posts perform best according to likes, saves, impressions, and more, based on different time frames: week, month, one year, and two years. Here are the measures you can see you through the Instagram app:

Profile

FOLLOWER COUNT:
Number of people following your account

IMPRESSIONS:
Number of times all posts have been seen

REACH:
Number of unique accounts who saw
any of your posts

PROFILE VIEWS:
Number of times your profile has been viewed

WEBSITE CLICKS:
Number of taps on a link in your bio

CALL/EMAIL CLICKS:
Number of taps to call or email you

MENTIONS:
Number of Instagram posts mentioning your handle

BRANDED HASHTAGS:
Number of posts with your personal branded tags

Stories

IMPRESSIONS:
Number of times the Story post has been seen

REACH:
Number of unique accounts who saw the Story post

EXITS:
Number of times someone exited the Story

REPLIES:
Number of replies to the Story post

PEOPLE INSIGHTS:
List of accounts who saw the Story post

Audience

GENDER:
Distribution of male and female followers

AGE:
Distribution of age range among followers

TOP LOCATIONS:
Top five cites and countries where
your followers are located

FOLLOWERS - HOURS:
Average times during each day of the week
when followers are on Instagram

FOLLOWERS - DAYS:
Days of the weeks when followers are most active

Posts

IMPRESSIONS:
Number of times the post has been seen

REACH:
Number of unique accounts who saw the post

LIKES:
Number of unique accounts who liked the post

COMMENTS:
Number of comments on the post

SAVED:
Number of unique accounts who saved the post

ENGAGEMENT:
Number of unique accounts who liked, saved,
or commented on the post

VIEWS:
Number of views of a video post

Live

LIVE VIEWERS:
Number of and list of accounts who
are currently watching

VIEWERS:
Number of accounts who saw any part
of the live video

If it ain't broke, don't fix It

This principle totally applies in the Instagram world. It's easy to be constantly stressed about creating fresh new content and reinventing yourself with a crazy cool idea every post. While it is great to push the boundaries and come up with wild new ideas, sometimes you just need to stick to your roots and double down on what does well for you.

Dig into your trends and analytics

I've said it before, and I'll say it again—look at those analytics and Instagram Insights. It's super handy for discovering your own trends, and it's a great way to see what types of posts kill it. Seven out of your top ten most-liked photos are selfies? Do some more! Photos of your beautifully decorated bedroom get saved like mad? Time for another post of the bedroom! This isn't to say that you should just do the same old thing over and over, but the analytics are there for a reason and clearly show which posts are providing value and inspiration to your followers.

My followers love my bed almost as much as I love my bed. See how many iterations I post of that cozy corner? That's because it works for me, and I really do spend a lot of time here. Plus, as you can see, I love reinventing it!

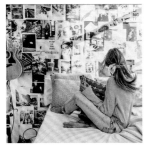
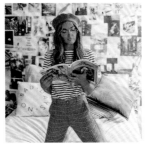

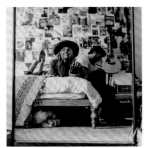

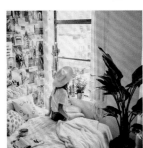

Riff on your bread and butter

As I've already mentioned, just because a certain type of post does well doesn't mean you have to do the same old shot over and over. You can riff on your trends and make them feel different and new while still sticking to what your followers know and love. Maybe photos of your office just absolutely kill it for you. Try a redecoration, include yourself or a friend or a pet in the shot, add some new props, or shoot it at a different time of day or night...the possibilities are endless.

Combine trends

Don't be afraid to combine trends, as well. You never know when two themes will mix like peanut butter and jelly and make something totally new and amazing. For example, combining the two worlds of lifestyle and fashion, finding ways to talk about both topics together, can be fun. Maybe you are traveling to Europe for the summer and want to share how you plan to pack, as well as how you planned your itinerary. Or maybe you want to share what you wore to brunch last weekend or how you make your tiny NYC apartment exciting! Within the lifestyle category, there is room to expand on so many difference topics. I personally always like to add a touch of fashion because it's a part of my brand and a part of who I am. Find ways to capitalize on what you're best at, and it will be easy to recreate those posts that do well.

Successes, failures, and faux pas

Making a living through Instagram is not always easy: it's filled with the highest of highs and the lowest of lows. There is nothing better than sharing a moment that connects, inspires, and gets a big response; and dang, there is nothing worse than exposing your creativity and vision only to have it flop. It's important to keep a few things in mind when navigating an Insta-career.

Remeasuring success

It's easy to focus on the big, obvious numbers on Instagram: likes, followers, and comments. However, if you dwell on those things too much, especially when just starting out, you can find yourself getting discouraged or comparing yourself to others. If I find myself doing this too often, I like to intentionally think about my success based on other criterion. Did you nail a new type of photo or pose you've always wanted to try? Heck yeah. Maybe you reached out to someone to collaborate when you otherwise would have been too nervous. Success. Don't get too caught up with the numbers; try to focus more on the creative and human aspect of succeeding on Instagram, and in time those numbers will grow. Some of my favorite and most personally successful posts are not the ones that got me the most likes and followers, but the ones that connected with people differently, were difficult to achieve, or expressed a new creative vision.

FAUX PAS

We've all committed Insta-faux pas before, and the experience isn't fun. Here are some common ones that should be avoided at all costs.

A guide to graceful failing

There's no worse feeling than that of public failure. When participating in an industry that is fast-paced and creativity driven, it's easy to experience feelings of failure. Here are times when I feel like I'm failing, and what I do to learn from them and move forward:

1. Dang, that post hardly got any likes

It is painful when you feel like followers aren't appreciating your art and hard work. Unfortunately the most basic and obvious way to measure that is by the Instagram *like*. If a post doesn't get as many likes as you think it should, don't let it bum you out! There are so many factors that go into how many likes a post gets: time of day posted, current events drawing people away from using their phones, tweaks to the Instagram algorithm that may adversely impact your post's discoverability, and the list could go on forever. It isn't always your fault that a post didn't get as many likes as it deserves. Take note of what the post includes, from composition to caption, and see if you can pull out any patterns to learn from for next time. However, most importantly, remember that if you loved what you posted, that's all that matters!

2. I set the bar too high

I find myself falling into this trap all the time. One day you'll the nail the ultimate Instagram post. The outfit, location, composition, and lighting are all spot-on perfect, and then the next day you'll be so bummed your outfit isn't right and the location is a mess. It's easy to get discouraged when you've set the bar too high, basing all of your success on the top photos you've ever posted. It's impossible to maintain this method; not every post can be a viral sensation. Each and every post serves a purpose, from scenic spacer shots, to accessory photos, to candid selfies. Not all of those posts will kill it, but they will contribute to the higher mission of your feed, and that's what ultimately matters.

3. A collaboration fizzles

After spending hours planning, perfecting, and shooting your post, it can feel terrible to have it discounted by the brand with whom you're collaborating. It's hard when two creative brands clash, but it's important to maintain a level head and communicate. Ask pointed questions as to why a brand doesn't like your post, and politely push back and explain your creative direction, if necessary. Use these moments of conflict to learn so the next collaboration is smooth as silk.

1. Nobody likes a troll

Don't be snarky and derogatory in the comments or DMs of your fellow Instagrammers. It's understandable to be offended sometimes by what certain people post, but rather than participating in the digital version of road rage—flippantly leaving snarky comments—use it instead as a moment to start a friendly discussion. Learn from someone else's perspective, and maybe make a new friend.

2. No copycats

Get inspired, but don't copy. It's never a good idea to copy someone's photo exactly, and people will notice. Although the Instagram community can seem huge, it's pretty tight-knit among the content creators. Copycats are easily noticed and lose credibility.

3. Beware of the humble brag

It's normal to want to show off your new designer bag, or to highlight the premier vacation. While it's one thing to desire to share the experience with others, it's another to come across a little too braggy. Make sure when sharing these awesome moments that you maintain a humble and authentic vibe; don't get too sarcastic, and avoid silly hashtags.

Cultivate brand relationships

As an aspiring influencer, you probably want to turn this hobby into a job. You want brands to notice you, send you their products, hire you for collaboration, and help you to shape your personal brand. Fostering good relationships with brands via Instagram can go a long way. It will be the first step to locking down collaborations, participating in giftings, and growing your following.

New collaborations

Brands want to work with someone with whom they connect and trust. It's very favorable to them if you do the legwork of reaching out and establishing a connection before they have to. It may take some effort, but if they like you and your content, then a new business opportunity will naturally follow. Keep a list of brands with whom you want to collaborate, and don't be afraid to shoot big. Also think outside the box; if you're a foodie who gives the best restaurant recommendations, give at-home cooking a try with a company such as Blue Apron to explore another avenue in the food genre.

Giftings

A full collaboration does not always come to fruition, but the opportunity for a gifting can still be on the table. Even if your favorite brands aren't running any campaigns at the moment, they may still be interested in you and your feed. You can always request a product, or they might even spontaneously send you something to potentially be included in an upcoming post. My advice is to always post about a gifting in some capacity, whether you quickly give a shout-out in your Instagram Story, or tag them in a post. It goes a long way in establishing a solid relationship with that brand and may lead to a paid collaboration down the road.

Expectations

Ask lots of questions up front, both of yourself and of the brand. Make sure you understand the campaign and how the brand wants you to fit into it. What type and how much content do they require? What is their creative direction, and how can you ensure it matches your personal brand? Will you need to travel, attend PR events, sign away copyright? Do You have time, and does this enhance your mission? Be flexible where you can, but it's necessary to ask these questions at the onset so that neither you nor the brand end up regretting the relationship.

Getting their attention

With some initiative, you can do so much to drive a relationship with the brands that enhance your authentic personality.

+ **Use their stuff; tag them in a post.**
 When you've identified a brand with whom you'd love to work, start wearing their clothes or capture yourself using their products. Post the photo and tag them in the actual photo, as well as in the caption or a comment. (It's sort of like pretending you are already collaborating with them.) For example, if you want to work with Urban Outfitters, then start wearing Urban Outfitters clothes in your posts, tag them in the photo and comments, and start using their hashtag whenever it's relevant. The brand's marketing or PR team is usually paying attention to how their tags are being used. If you're posting good content that highlights their brand, it really increases your chances of a collaboration. This is a good first step to fostering a working relationship.

+ **DM the brand.** A brand's Direct Message inbox is also usually managed by someone on the brand's marketing or PR team. If you're trying to get noticed, shoot them a concise and professional DM to get the conversation going. It may take a few tries, but it's worth the effort. DM attempts work especially well in combination with the above method of using their products and tagging them.

+ **Search LinkedIn.** If you really want to work with a particular brand, search the company on LinkedIn, and skim through the list of employees for ones with relevant roles. Look for a person in marketing, or for someone who deals with social media influencers. From there, shoot them a message to start the conversation. This helps you skip a lot of the impersonal contact attempts and gets you straight to people who make things happen.

Slurpees are better than Burpees. And comfy t's are better than crunchy t's. @urbanoutfitters #uoonyou

Insta-do

+ Be patient. Scoring paid collaborations takes time, and you might not get any bites until your follower count has grown some more, or your feed looks fuller and more consistent. However, giftings are super realistic for anyone with an engaged audience.

+ Be proactive. Stuff *might* start ending up on your doorstep, but if we're being realistic, you probably need to make the first move if you're new to this. If you're serious about making an Insta-career, you really should reach out first.

+ Be professional. You may be an artist, but you're also a business boss. Always be timely. Learn to craft messages with clear, actionable points or questions. Asking for a collaboration? Then just ask up front, and don't dance around the point with lengthy prose. You can still have a personality, but correspondence should be concise, direct, and grammatically correct.

+ Be picky, but polite. If a brand does not fit your personality, don't accept their products, and don't post about them. However, don't ignore them if they reach out; you should politely decline, return their product, and even give them a recommendation for an influencer you think would be a better match.

Sponsored posts

As you build your audience, gain the attention of brands, and try to get in on the influencer-marketing action, sponsored posts will be the main source of income. While a sponsored post is a great way to make money, and is the first step toward monetizing your following and establishing your career, it's important to do sponsored posts the right way. You are not a giant billboard, and you don't want to overwhelm your followers.

You're not a billboard

I try to post at least five or six non-sponsored posts for every one sponsored post. This allows my feed to remain natural and authentic, and I don't annoy my followers with too many ads. With every post, you're either gaining or losing social capital, and the reality is that too many ads can really diminish the trust of your followers if you're not careful. It's important to remember why you started your Instagram account and not lose sight of that when money is being offered for posting. Recall your mission and make sure you're still delivering the content you set out to in the first place.

Keep it natural

Make sure you're working with brands and taking on campaigns that are natural to you, your feed, and your following. Keep in mind your niche and what followers are interested in—try to stick with that. If a sponsored post feels inauthentic, or even if it's too blatantly an ad, your followers may get turned off, and you will start to lose credibility. Keep it natural and real, and stick only to sponsored posts you believe in.

How much should I charge?

A good, general starting point when deciding how much you should charge per post is the 1 percent rule: charge in dollars 1 percent of your follower count, or $100 for every ten thousand followers. The Instagram influencer space is very new, and kinks are still being smoothed out when it comes to charging per post, but this rule gives you a ballpark range to start. From there, you should negotiate with the brand to nail down a more specific rate based on what's required of you for the campaign package. Some brands want you to share the content across your social channels (Facebook, Twitter, etc.). Other times, you may be asked to compose a blog post, as well. Sometimes brands may want to use your images for other marketing reasons (email campaigns, catalogs, etc). If any of these circumstances occur, it's a perfect opportunity to increase your rate. However, also consider that you may want to give a little bit on your rate if the brand is prestigious or has a large and engaged following. In these cases, the soft value of the relationship—the clout that accompanies association with a super prestigious brand—may be worth more than a dollar value.

Legal precautions

As more money has been dumped into the influencer marketing space, the Federal Trade Commission has taken notice and started to crack down and regulate the industry to guarantee that users are always clearly signaled when a post is sponsored. Ensuring that you're in the legal clear must be taken into account every time a post is sponsored. However, I'm not an attorney, so you should seek professional legal advice before you begin to promote products on your feed. FTC regulations are relatively new to everyone in the space, and it's a learning process, but here are a few precautions I've learned:

1. Disclose partnerships with a #hashtag

This depends on the partnership and the legal agreement, but sometimes you can get away with disclosing the nature of the post through a hashtag. Acceptable options usually include #ad, #brandPartner, or #sponsored. The brand's legal department should help you decide what is adequate, and there may be precise specifications in your contract.

2. "Paid partnership" integration

If a brand you're working with has a business profile, they can opt for your campaign to run through the "Paid partnership" integration method, which is offered directly in the app. You may have seen this on posts from some of your favorite Instagrammers; directly under their name on your feed, it will say "Paid partnership with —". If a brand elects to do this, there are some further settings you'll need to apply to the post to make it happen.

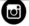 Roses are red, peonies are too, here are some flowers I picked for you! @DSW just launched their new #DSWVIPrewards program. #sponsored

Use affiliate links

Lucky for you, there are companies out there who reward you for sales performance and for the traffic and clicks you bring to their website. These are called affiliate links, and they can be a fantastic way to earn money and build rapport with brands you want to work with or are already working with. An affiliate link is a unique link generated by a third party; it tracks when people click or buy through that link. For example, you could get your own, unique affiliate link to some shoes at Nordstrom. The webpage for those shoes will look normal to everyone clicking on it, but there will be some extra tracking magic under the hood so you know when you actually generated a sale.

The nuts and bolts

All affiliate companies work differently, but more often than not, you have to apply to get into their system and receive access to all the brands with whom they work. You could easily use the swipe-up Story feature in Instagram to your advantage, helping users immediately access an affiliate link and earning you some extra dough. However, since link support is otherwise not optimal on Instagram (remember, only links in your bio are clickable), affiliate links are often best with the support of your other websites. Get creative and integrate your Instagram posts with your blog, Twitter, Facebook, etc. That way, you can capture your audience's attention with an Instagram post, then help them to easily navigate to your blog where there is easy access to your affiliate links.

Calling all tech nerds, fashion lovers, and beyond

If you are a tech nerd or a fashion lover, there are many companies out there who are set up for you to offer products across the spectrum. These are some of the major players—Reward Style, Amazon Affiliates, Shop Style, ShareASale, and Linkshare—but if you do a search for affiliate programs within your niche, you'll find so many options. Do some research to figure out what may be a good fit.

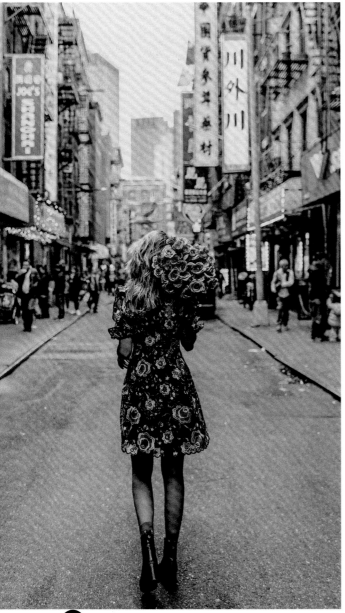

Dear Flowers, I thought you were pretty way before instagram did. http://liketk.it/2tQM1 #liketkit @liketoknow.it #tezzanyc

Affiliate link!

Back to authenticity

Many people can make quite a large income off of affiliate links, so I think it's important to be transparent and authentic when showcasing these links in your work. People want to trust you and know you are sharing a product link because you yourself genuinely use and appreciate it. If you don't disclose that you're making money off of a link, they will feel as if you're taking advantage of them or promoting something that's not really all that great.

Learn what your followers love, and launch a product of your own

Instagram is increasingly becoming a better and better launch pad for products of your own, and the tracking capabilities of affiliate links are an excellent way to determine what products your followers are interested in. Do you notice that every time you post a new swimsuit via an affiliate link, your followers buy it like crazy? Maybe it's about time you get going and finally launch that swimsuit line. Not only can these affiliate links provide an extra source of income, but they can also provide invaluable data to help take your Insta-brand to the next step.

REFRESH THE LINKS
If you have a post that receives continual traffic, even months and years later, try to update those affiliate links with new products that are in stock so you can still earn on those posts.

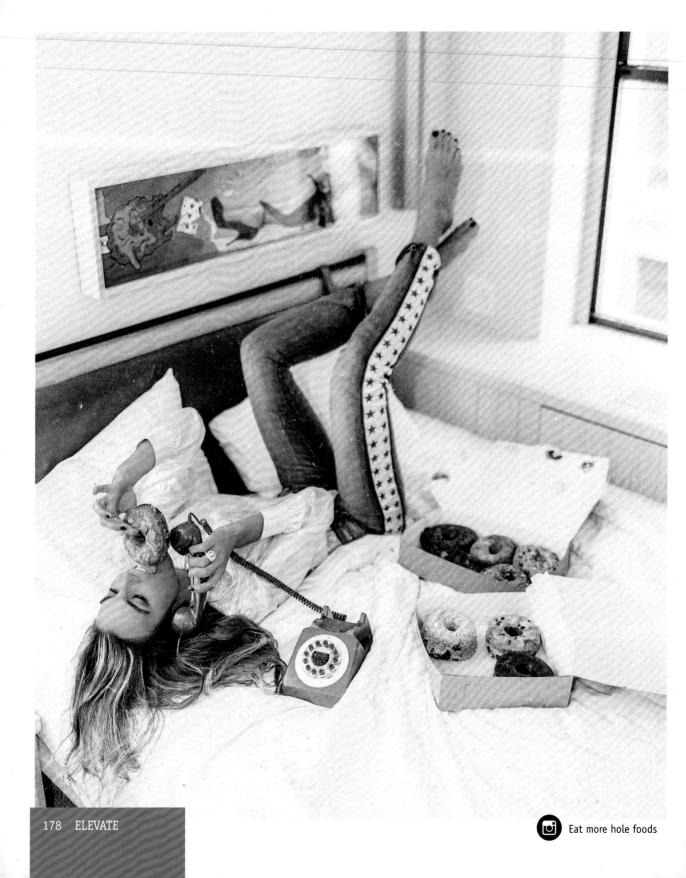

Eat more hole foods

Find representation

As you continue to grow your Instagram and get more serious about pursuing it as a career, you will realize the amount of work required is immense; some management help goes a long way. From answering emails to pitching you to brands, a manager will help you achieve Insta-success. However, you don't want to find just any management—it's super important to find the right management.

Ask around

As you network and make friends in the Instagram world, the topic of management will inevitably come up. Pay attention to the campaigns your fellow Instragrammers are getting; if they're working with brands you admire and would also want to collab with, then their management group might be a good fit. Ask around to get feedback on different management groups. An Insta-friend may even be able to provide you with a very helpful introduction to get your foot in the door. There are more and more groups popping up, so if you ask around enough, you will surely stumble onto a few solid options.

Make a media kit

You can't reach out to agencies empty-handed—you need to make a nice, concise argument for yourself. A media kit is a simple, usually one- or two-page document that gives a high-level overview of who you are, what you have to offer, and why you're a good candidate for being represented. It should include a photo or two, a little blurb or mission statement, and follower demographic information: gender, location, follower count, etc. Once you've made this, as well as compiled a list of management groups you want to contact, write up a little email and send around your media kit. This is a good first step toward getting your foot in the door while letting a potential manager know what you're all about. You may be just the Instagrammer a management group needs.

Do your research

If you Google "influencer agency" you'll get tons and tons of hits. As I've said many times, this industry is booming, and agencies are popping up all over the place to get in on the action. Dig into some of the top players, and some of the smaller ones, too. You can learn a lot by visiting their websites, examining case studies, and checking out the roster of influencers they currently represent. As you curate your list of dream agencies, reach out with your media kit to get the ball rolling. As it is such a booming industry, if you have an audience and a brand of your own, you'll find someone to represent you if you put some effort into it.

Top dogs vs. smaller players

There are benefits to agencies both big and small. At a big agency, you may be a smaller fish, but at least it's in a bigger pond, containing Instagrammers with much larger followings and connections. These could leverage you to the next tier. In a smaller agency, you will receive more one-on-one attention that can help individualize your path. The size of the agency totally depends on what you're looking for. Maybe you look up to some of the top Instagrammers at a large agency and want to connect with them and work together; or perhaps you really connect with a manager at a small agency, and the more focused attention means a lot to you. Look around, put yourself out there, and talk to people. You'll surely find the right fit.

The wide world of social media

With so many massive and engaging social media platforms out there, it doesn't make sense to limit yourself to just one. Expand your audience and grow your brand by sharing your personality and content through other avenues. I know it can seem overwhelming, as just worrying about one can be draining, but each platform offers a different way to express yourself.

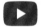 YouTube

YouTube is *huge*, and its users are super engaged, so being active on the platform brings an immense amount of potential for growing your audience. It can be challenging, especially if you're like me and usually more focused on photos rather than video. With that said, do YouTube in a way that makes sense to you. I'm not very good at making vlogs (video blogs), but I do love making high-energy videos to music, so that's what I stick with. Poke around for content creators whose videos you like, and see if you can learn a little bit about their process, or if they hired a video producer. Don't worry about doing YouTube how everyone else is doing it; find a way to use it that fits into your flow, and use the YouTube community to share your mission.

+ **Keep it short.** Don't feel like you have to make super long videos. Maybe you have some highlights from a trip, or a quick message to share that just makes sense as a video—go ahead and post it! There are no rules.

+ **Always be filming.** I try to make a concerted effort to switch over to video mode to get some clips when shooting photos. If you're in a super beautiful location that would provide some great video content, grab a bit of footage after you're done getting photos. It's a great way to kill two birds with one stone and to always have video content on hand.

+ **Set goals.** Put some accountability on yourself to get a video out in a cadence that makes sense. Maybe start out with just one to two videos a month. This will help you get used to creating and sharing on YouTube. When you start to feel more and more comfortable, bump up that goal to one video a week, or whatever makes sense for you.

Facebook

Luckily, sharing between Instagram and Facebook is a very easy thing to do. The two platforms are tightly integrated, as Facebook actually owns Instagram now. In fact, you can automatically share straight to Facebook (and Twitter and Tumblr) every time you post on Instagram. This is another great way to maintain activity on both platforms. While this is nice and easy, I do recommend trying to post things exclusively to Facebook so it's not just a mirror of your Instagram. Throw up a status update, comment on your friend's photo, or upload some outtakes as part of a photo album that you wouldn't upload to Instagram. Just make sure to provide some unique content to mix in with your auto-shared Instagram posts.

Twitter

Twitter is also seamlessly integrated with Instagram, allowing you to post to both platforms at once. It's great for maintaining activity on Twitter, but again, I do recommend interspersing content exclusive to Twitter here and there so it's not just an Instagram mirror. Show off your wit and personality, share funny or interesting quotes, or even link to content on the web you find interesting. It takes a concerted effort to be active on each platform across the board, but it's worth doing as you will learn so much about your audience. Maybe when you start sharing on Twitter, you'll realize it comes naturally, and your audience will grow there even more than on other platforms. Just go for it and get sharing.

Pinterest

I love Pinterest. I think it is one of the most beautiful and engaging platforms out there, and I'm constantly using it to find inspiration. I do try to consistently post my own content to it as well. If I have a shoot that I'm super excited about, I'll share some of the photos from it on my public Pinterest board. You never know who will pin it, so always make sure to link it back to your Instagram profile. It's a great way to drive more traffic to your feed and to further build your audience.

Blog

I recommend creating a blog to anyone starting on Instagram. No matter what happens to Instagram or any of these other social media platforms, your blog is the one thing that can exist on its own without fear of platform tweaks and changes. It's your place to further expand your message, expound on ideas that just won't fit on Instagram, and post a wider variety of content.

+ **Pick your blog provider.** While I have been a Blogger user for a while, I also highly recommend using WordPress since it's easily customizable, has many templates, and is an overall refined platform. Check out which providers other bloggers you like are using, and find one that fits your needs. It's easy to get a blog up and running in minutes, even with your very own custom URL. What are you waiting for?

+ **Set a blog posting schedule.** Try to get blog posts out regularly. I've noticed being active and consistent is the best way to grow and maintain an audience. Start out posting once a week, then twice, then however many times per week you can maintain. Consistency is key.

+ **Keep it fresh.** Think of blog post ideas that are outside of the box. Trying a new diet or workout schedule? Saw an interesting play? Just getting into meditation? Whatever it may be, keep your blog content new and exciting. You never know who you may connect with or what doors you may open up with a unique and engaging blog post.

+ **Cross-promote to your other platforms.** Your blog is a great place to promote your YouTube, Twitter, and Instagram accounts and vice-versa. Hint at a new blog post on your Instagram account and share the link in your bio, or tweet out updates when you have fresh new content. Cross-promoting yourself through your various social media accounts is a great way to direct traffic through your blog and further solidify it as a pillar of your online presence.

More tools for your toolbox

Don't limit yourself to just one app or program when editing photos and creating content. There are so many high-quality and easy-to-use apps out there; you should become familiar with as many as you can to add some extra tools to your Instagram toolbox. Getting experience with different editing and content-creation apps will further set you apart from the rest of the crowd and expand your creative boundaries.

VSCO (mobile)

This is the top dog when it comes to high-quality editing on your phone. The breadth and depth of tools they have is absolutely astounding, and everything is so high quality. I especially love them for the photo filter selection. The VSCO team has perfected creating beautiful filters that are so tastefully done. Nothing is too cheesy or over the top; their filters are just beautiful all around. They have dozens and dozens to choose from, so the possibilities are massive. I recommend playing around and testing a bunch of filters until you find just a few that you love so you can maintain some consistency. Not only can you apply all of these incredible filters to your photos, but you can also apply them to your videos so you can keep your aesthetic totally consistent across the board. VSCO is free to download, but there is a small annual fee if you'd like a subscription to access all of their tools.

Afterlight 2 (mobile)

Afterlight 2 comes in at number two of my favorite mobile-editing apps. While they also have a great selection of filters to choose from, I don't love them quite as much as VSCO's. That is just my preference though, so check it out for yourself; you could find a few you like better. The main reason I love Afterlight 2 is for their Dust textures overlays. They have a wide selection of subtle dust and grain overlays you can put on top of your photos to give them a vintage and filmy feel. They're great and easy to use and can give your photos the right amount of extra vibe when you're looking to mix it up.

Lightroom (mobile)

This is Adobe's premier mobile-editing solution, and it's pretty dang good. If you're familiar with Lightroom on the desktop, you'll feel right at home with this app. There are even ways to transfer your desktop Lightroom presets to the mobile app, which can be really handy if you need a high-quality edit in a pinch. If I really want to dig deep into editing a photo on my phone, this is what I'll use, as it boasts really handy, granular, color-control tools. It is about as close as you can get to a desktop-editing experience on your phone.

Lightroom (desktop)

I am an avid Adobe Lightroom user on my Mac. Since I come from a photography background and take 99 percent of my photos on a DSLR, I am constantly editing in Lightroom on my computer. The ease-of-use combined with the sheer power of the program make it the ultimate editing tool. I love that I can save the editing presets I have created and reuse them on photo after photo to hone my unique aesthetic. You can tweak every little thing when it comes to color, contrast, saturation, exposure, and everything in between. There is a bit of learning curve, as it is geared more toward professional photographers, but there are plenty of online videos and tutorials (and tutorials built into the program) so that you can pick it up pretty easily and get editing like a pro in no time.

Photoshop (desktop)

Pure magic. I'm mind-blown at all the insane tools Adobe Photoshop has to offer, and I learn more each time I use it. I mainly use Photoshop for editing out annoying little things in photos and videos. A pesky bystander in the background that just wouldn't move? Edit them right on out. It's super handy when you just couldn't get your photo to perfectly line up that day and need a little extra Photoshop magic to make it pop. The learning curve here is even steeper than with Lightroom, but again, there are many tutorials to walk you through it and teach you anything you could possibly want to know.

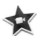 iMovie and Final Cut Pro (desktop)

 These are my go-to programs when creating videos for Instagram. I used iMovie for years, and its simple but powerful tools worked well for me. However, over time I wanted to create more complex videos with a little more going on in terms of editing, text, and transitions, so I made the jump to Final Cut Pro. It was super easy to get the hang of after being an iMovie user, and it has been a great tool to have in my back pocket when I want to edit up a cool little video for Instagram. I recommend you start off with iMovie. It is cheaper and easier to get going, and it will probably suit the needs of most users wanting to create simple yet cool Instagram videos. If you find it's not enough for you, it's really easy to make the jump to Final Cut Pro.

Index

T-U

V

W-X-Y-Z

About the author

Tezza (a.k.a. Tessa Barton) is an artist, musician, and Instagram influencer. Through her beautiful, unmistakable photo aesthetic, she loves to inspire others to be creative and to live the art of life. She is originally from Salt Lake City, Utah, where she received a bachelor of fine arts with an emphasis in photography. She attended Parsons School of Design in high school where she developed a love for fashion that has carried over into everything she does. She is the lead vocalist, songwriter, guitarist, and keys player in the bands Luna Lune and Doe. She now lives in New York City with her husband, Cole Herrmann. Her personal brand encompasses her Instagram account (@tezzamb), her blog (bytezza.com), and her product line (Tezza), which specializes in fashion, photography, and lifestyle products.

Author's thanks

I would like to thank my best friend, business partner, and husband for helping me turn a dream into a reality, taking ALL of my Instagram photos, and living each day of life to the fullest.

I would like to thank my sister Sophie Rose who is no longer on this earth for being the inspiration of my life, living every day like it's the last, and teaching me to feel the fear and do it anyway.

I would like to thank my parents for not just encouraging me, but pushing me and helping me pursue every interest in life I ever had.

I would like to thank my mother for being a strong and smart woman who started her own business at age 23 and never looked back. I could only hope to be like you one day.

I would like to thank my three brothers for answering every text I send trying to determine which photo is best to post on Instagram.

I would like to thank all my friends and followers, and of course Instagram, for creating such an amazing platform we can all connect on!

Publisher: Mike Sanders
Editor: Alexandra Elliott
Book designer: Rebecca Batchelor
Proofreading: Lisa Starnes
Indexing: Celia McCoy

First American Edition, 2018
Published in the United States by DK Publishing
6081 E. 82nd Street, Indianapolis, Indiana 46250
Copyright © 2018 by Tezza

18 9 0 1 2 0
001-311017-OCTOBER2018

ISBN: 978-1-4654-7668-5
Library of Congress Catalog Number: 2018940675

DK books are available at special discounts when purchased in bulk
for sales promotions, premiums, fund-raising, or educational use. For
details, contact: DK Publishing Special Markets, 345 Hudson Street,
New York, New York 10014 or SpecialSales@dk.com.
Printed and bound in China

The publisher would like to thank the following for their expert insight
and kind permission to use their photographs:
Emily Luciano: 108–111
Aggie Lal of Travel In Her Shoes: 112–115
Erin Jensen of The Wooden Skillet: 116–119
Alanna Durkovich of Xander Vintage: 120–123
Amber Fillerup Clark of Barefoot Blonde: 124–127
Alexa Jean Brown of Alexa Jean Fitness: 128–131
Anne-Marie Barton of AMB Design: 132–135
Carissa Smart of Design By Aikonik: 136–139

A WORLD OF IDEAS:
SEE ALL THERE IS TO KNOW
www.dk.com